Shooting the Darkness

Iconic images of the Troubles and the stories of the photographers who took them

TREVOR DICKSON • PAUL FAITH • ALAN LEWIS • STANLEY MATCHETT
MARTIN NANGLE • CRISPIN RODWELL • HUGH RUSSELL

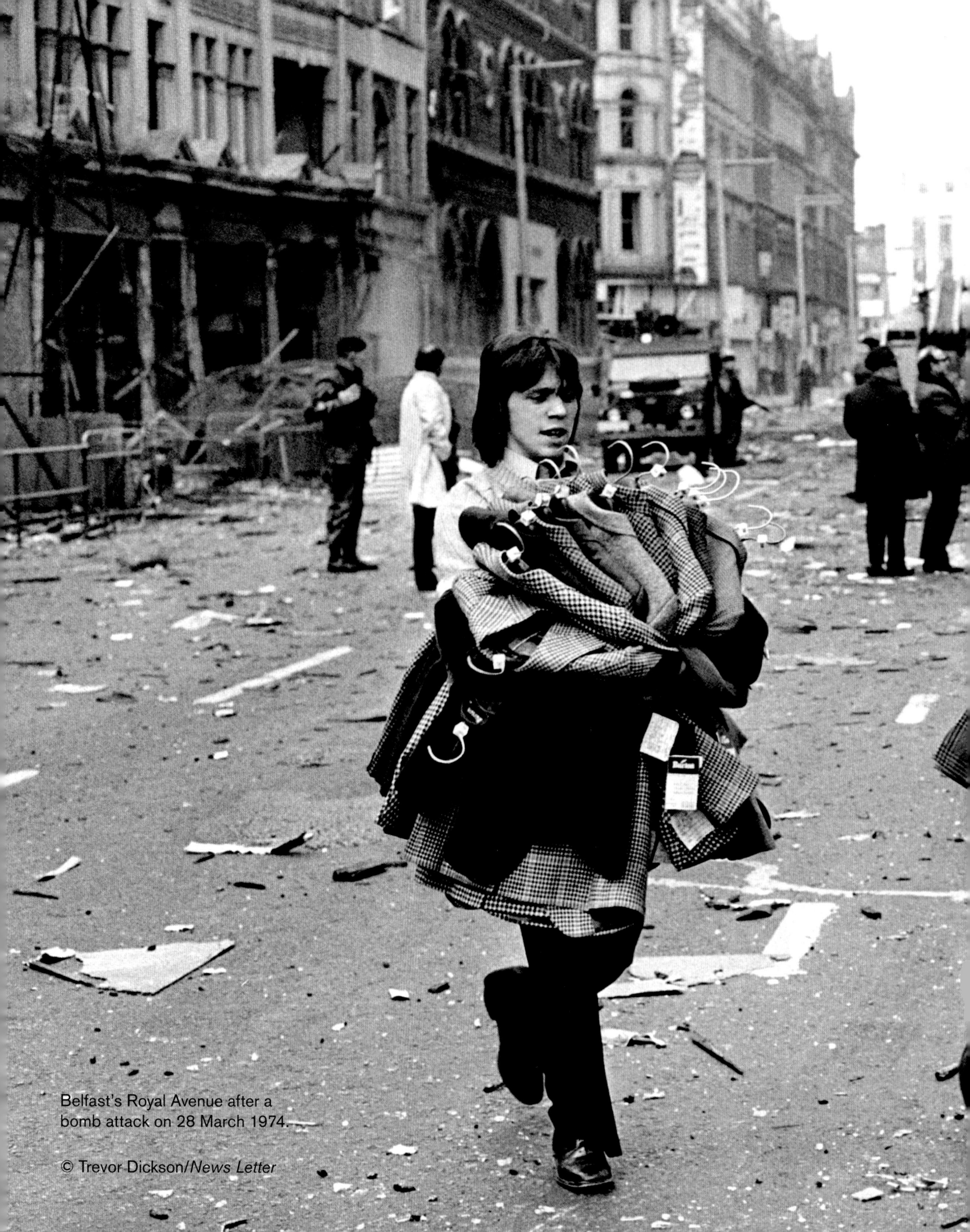

Belfast's Royal Avenue after a bomb attack on 28 March 1974.

© Trevor Dickson/*News Letter*

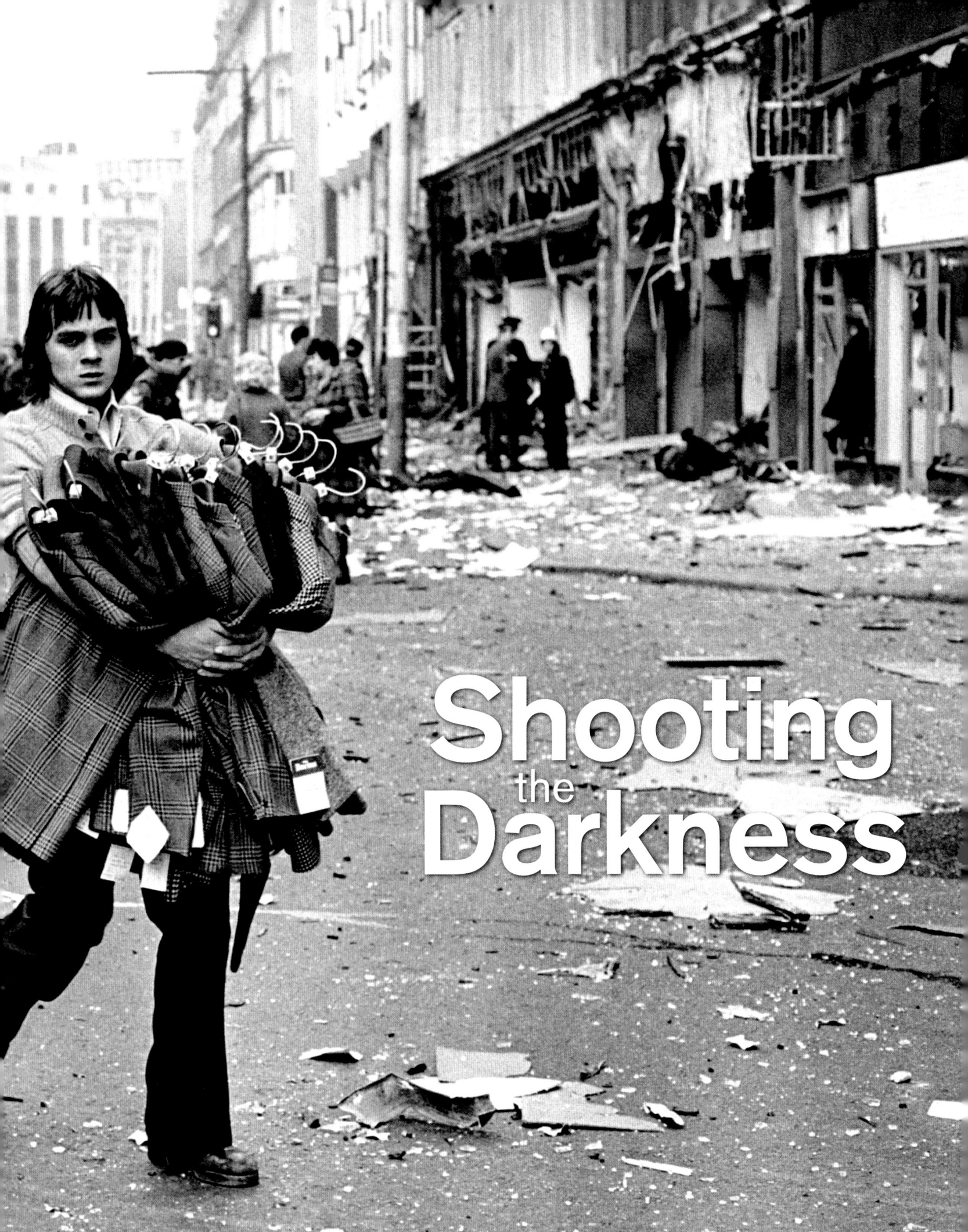

Shooting the Darkness

This book is based on the documentary, *Shooting the Darkness* (2019), directed by Tom Burke and produced by Thomas Kelly for Broadstone Films.

First published in 2019 by Blackstaff Press
an imprint of Colourpoint Creative Ltd
Colourpoint House
Jubilee Business Park
21 Jubilee Road
Newtownards BT23 4YH

© Introduction, Tom Burke, 2019
© Individual chapters, the photographers, 2019
Photographs on pages:
 x, 2, 4, 5 © Stanley Matchett
 3 (top) and 7 © Stanley Matchett/*Belfast Telegraph*
 3 (bottom), 8–9, 10–11 (top), 11 (bottom), 12–19 © Mirrorpix
 ii–iii and 20–39 © Trevor Dickson/*News Letter*
 43 © Victor Patterson
 40, 45–58 © Alan Lewis
 60–75 © Hugh Russell/*Irish News*
 76, 90–1, 92–3, 114–133 © Pacemaker Press International
 78–89 © Martin Nangle
 94–113 © Crispin Rodwell

All rights reserved

The photographers have asserted their rights under the Copyright, Designs and Patents Act 1988 to be identified as the authors of this work.

Printed and bound in Italy by Rotolito S.p.A.

A CIP catalogue record for this book is available from the British Library

ISBN 978 1 78073 239 8

www.blackstaffpress.com

CONTENTS

Introduction
Tom Burke vi

'The camera was always on my desk with a fresh roll of film in it'
Stanley Matchett 1

'Our job was to be right in the thick of it'
Trevor Dickson 20

'We showed what was happening as honestly as we could'
Alan Lewis 40

'The older I'm getting, the more I'm starting to realise that we were doing something special'
Hugh Russell 58

'That's the nature of working in a job that you're passionate about – you're prepared to take a risk'
Martin Nangle 76

'There's intuition and instinct, but on top of that there's luck'
Crispin Rodwell 94

'We take pictures; we don't take sides'
Paul Faith 114

About the photographers 134

Introduction
Tom Burke

For a brief period in 2006 I worked on the picture desk of a national newspaper in Dublin. My job involved sourcing pictures for the stories on the news list on any given day, assigning jobs to a team of staff photographers and liaising with freelance 'snappers' all over the country. We had a map of Ireland on the wall with the name of a local operator in each region that could be relied upon to take our call and supply what we needed. Covering half of Northern Ireland in blue marker was the name Alan Lewis.

I spoke to Alan many times that summer and invariably our calls would end with him reporting a successful assignment and that pictures were on the way. Each time I put down the phone my boss would say, 'You know, Alan Lewis has some great stories!'

A national newsroom is a fascinating and energising place to work and the imagery being generated by the photographers ran the gamut from the tragic to the frivolous. When I moved back into the documentary world I had the idea of developing a film about the daily lives of press photographers. The pitch was to show how the pictures in the newspapers got there and to open a window on to the working lives of the photographers who had taken the images. I thought the variety of the work made the profession unusual. At one moment, you might be at a glamour photocall, the next you'd be covering loss of life at a road-traffic accident. I remembered how bored the photographers were when they came from the former, and the clear emotional impact the latter had on them. I loosely pitched the idea to Frank Miller at the *Irish Times*, who said, 'If you're going to do it you really need to go up north and capture the guys up there. They really saw a lot.'

Fast-forward a couple of years and I'm in the back of a black taxi heading up the Antrim Road in Belfast with Alan Lewis giving directions. We had met in person for the first time a couple of hours earlier and I had quickly known two things: I like him a lot and he does indeed have some great stories. His mind is a well-organised archive of the events he has covered, the images he has shot and the few images he has missed. Alan has invited me to Belfast on this evening because in the back room of St Malachy's Old Boys' Association there is a meeting of Hugh Russell's camera club. The Northern Ireland Press Photographers Association is giving a retrospective slideshow to the club that night covering their forty-year history. Over the course of the evening, their work charts a history from quaint regional normality, the descent into the chaos of the Troubles, the emergence of the peace process to the relative prosperity of the recent past. The photos are beautiful, disturbing, exhilarating, affecting and world class in standard.

When one of the images appears on screen the photographer is invited to tell the story of its creation. This is how I first hear these men speaking about their images. Stanley Matchett speaks about Bloody Sunday; Trevor Dickson speaks about his 'Tar and Feather' image; Alan Lewis talks about the Sean Downes photograph and Hugh Russell talks about a man killed while washing his car. The atmosphere is, at times, solemn. Those who are speaking are listened to. There is a sense of collective experience, that all of these people have lived through the same events, often standing

Introduction

shoulder to shoulder. There is also the camaraderie that comes with this. Hugh Russell describes the group as a band of brothers. In one picture, the photographer says that Hugh can be seen in the bottom of the frame taking cover during a bomb attack, to which Hugh rapidly responds, 'I wasn't taking cover, I was taking bloody photographs.' I leave that evening feeling like I have been let inside a small society that has a story to tell and is ready to tell it.

I met Stanley and Maureen Matchett in the Linen Hall Library in Belfast to discuss the project. Stanley invariably brought large folders full of prints with him. Some pictures he was used to speaking about in public and he had a rehearsed narrative that came quite easily to him. Others made him pause and seek out the memory. It was the range in his folders that was extraordinary. Full-colour album covers for comedian James Young or for the Clancy Brothers followed by 'weather pictures' of pretty young things on the beach would give way to the black-and-white horrors of the early 1970s. The joviality of the former made the descent into violence all the more shocking. Often these events were happening side by side, on the same day, in the same city. Stanley would be dispatched to the seaside in the morning only to be covering carnage that afternoon. I'll never forget when, at our second meeting, he told a jolly story about buying two girls an ice cream at the beach before they posed for a shot. He turned the page of the scrapbook to reveal a chaotic scene featuring a fireman lifting something on a large shovel. He looked at the picture quietly for a minute before saying, 'I think some of the bodies were not intact after that one.'

Soon afterwards, Thomas Kelly, who produced the film, and I met Paul Faith in a cafe in central Belfast. I'd seen Paul's byline a hundred times on images in the news but that was no preparation for meeting him in person. Here was a great photographer who was also a great storyteller. Impeccable recall, humane, witty – brilliantly structured stories flowed from him so quickly that Thomas, who was taking notes, found it hard to keep up. At another early meeting, Crispin Rodwell was equally impressive – a dyed-in-the-wool press operator who could speak with candour and eloquence about what he had seen, and who was clearly happy to be asked his opinion after decades of only speaking through his pictures. Trevor Dickson, like Stanley, saw his home place change drastically in front of this lens and kept an immaculate archive that was better than any newspaper's. In his scrapbooks, showbands gave way to gunmen, bonny babies were replaced by endless funerals. When we spoke, he was quite clear that he never suffered from nightmares or flashbacks.

Over the months, as these early conversations took place, themes started to emerge organically. We went into the process with two questions for the photographers: What did it take to get the picture? What did it cost you? The first was answered with a description of process. The second is where the real heart of the film, and this book, lies.

Though these photographers worked for different newspapers and agencies and covered different timeframes of the Troubles, the common threads of their experiences were striking. Early on, we heard them refer to the camera as a 'shield'. Paul Faith adopted a mindset that nothing was real beyond the end of the lens. If something terrible had to be looked at, it could be looked at through the viewfinder and on that screen it need not be real. You might take the camera down from your face and not look at the horror with your own eyes. Martin Nangle described his own process for protecting his mental health in similar terms, ascribing an unreality to anything seen

Introduction

via the camera. This allowed him to successfully disassociate himself from the chaos of his surroundings and to continue to work, or to allow the camera to continue to work. Each of the men, consciously or otherwise, developed some kind of defence mechanism to keep the violent charge of what they were witnessing at arm's length.

There were stories of heart-wrenching 'collects', when photographers had to call at victims' homes to ask families for an image of their loved one for publication. Even now, when social media has made such knocking on doors unnecessary, the thought of doing it again made them feel nauseous. On such an assignment, Hugh Russell was sent to the wrong house and had to tell a grieving mother that, in fact, her son was not dead. Alan Lewis stood outside the house of a murdered friend to keep other press away as her mother had no idea her daughter was dead. As a collective, they designed a way of covering funerals with long lenses and sensitivity so as not to compound the grief of families. All agreed that the behaviour of the foreign press at such events was deeply insensitive, symptomatic of the fact that those journalists did not have to live in the same small place week after week, year after year. The film is a story of local photographers who unwittingly became war correspondents. They didn't strike out in search of adventure and conflict – the war began around them. They were working the streets of their own home towns, so the pictures were never just pictures, the stories were never just stories. Everything was of consequence.

Martin Nangle describes press photography as the quest for 'today's picture'. What is the image that has the most relevance today and today alone? All of the mechanics of the job are geared towards getting that picture into tomorrow's paper. The photographer is the first part of this chain of events, shooting maybe thirty-six or seventy-two frames on a particular assignment. The first edit of the images is based on the negatives and maybe prints of a few of them. Only two or three of these pictures will be submitted to the paper. The ultimate decision on which one is chosen takes place far away from the photographer. In the newspaper the photograph is paired with a headline and a caption. The photographer who originated the image loses control of the context. Today's picture is then rapidly superseded by 'today's picture' of tomorrow. The news cycle constantly moves forward. The photographer moves on to the next job and a collection of 'today's pictures' accumulates around the office or darkroom, often not filed, catalogued or valued.

These images can therefore come to be seen as transient, disposable, soon to be wrapping for fish and chips. Today's picture becomes irrelevant as early as tomorrow. With the passage of enough time, however, this collection of 'today's pictures' results in a day-by-day visceral record of the past. Patterns emerge and contexts evolve. The images can now be freed from their initial home in the newspaper and looked at with new perspective; the perspective that comes from knowing what happened next, knowing how today's picture is connected to what went before it and what came after it. The work of these press photographers represents an unparalleled visual archive of Northern Ireland during the Troubles. What was once instant and disposable now becomes comprehensive and essential. The very quotidian nature of the job, the fact that they were working stories day in, day out, means that very little escaped their view. There is a first-hand value here that fine art photography simply cannot compete with. Coming along sometime afterwards, an artist may create an image that explores the meaning and implications of being shot with a plastic bullet, but only Alan Lewis was able to capture the moment that Sean Downes was

shot and killed by one. You will never capture the horror and tragedy of that moment after the fact. You must be present in the moment and these photographers always were. As Martin Nangle puts it, 'You are that eye, you are that reporter, you are that photojournalist.'

Three years on Thomas and I are back at Hugh Russell's camera club to present our film to all seven photographers. The reception is warm, happy even, but with inevitable questions about what didn't make the cut. As with any medium, there are limits to what a television documentary can do. We must conform to a running time of fifty-two minutes, cover a manageable number of incidents and characters so as not to overwhelm the viewer, and we must be mindful of distress that can be caused by graphically violent images. Hugh Russell believes that the power of a still image lies in its unchanging nature: 'It's the same from the first moment you look at it till the last.' In a film, images replace each other frequently as the narrative moves on, the pace being governed in advance for the viewer by the filmmaker. The printed image in a book has no such limitation. Readers of this book can decide which pages to linger on, which ones to move past and which stories to read. In preparing our film we recorded dozens of hours of interviews with these photographers and looked at hundreds of their images. All of this was rendered down into less than one hour of screen time and we knew that there were many more stories for the photographers to tell, many more images to be brought back from the archives. This book is an excellent forum to further expand the scope of the film, to further reveal the value of these photographers' contributions to the historical record of Northern Ireland. They witnessed the Troubles first hand on behalf of their own tribe and they did so honestly. Whatever it cost them to do this work, to see the things they saw, they have come through with their humanity intact. The pictures survive, to be viewed, discussed, interpreted and understood by those open to heeding warnings from history.

Tom Burke is a documentary filmmaker based in Dublin. He directed the critically acclaimed documentary *Shooting the Darkness* for Broadstone Films.

'The camera was always on my desk with a fresh roll of film in it'
Stanley Matchett

I was employed by a civil engineering company that was constructing the first eight miles of motorway in Northern Ireland, from Belfast to Lisburn, and the man in charge of everything decided that I was a good enough photographer to shoot pictures for the firm. I had a Rolleiflex at that time, which is an example of first-class German precision engineering. It was a great camera – I loved it. I soon became very proficient at producing good-quality glossy prints. I was sending freelance pictures to the *Belfast Telegraph* and every one of them was being used. A colleague suggested that I should meet the picture editor and the assistant picture editor. That was good advice and I took it.

Some time later a photographer's job was advertised and I got an interview. The editor, John Sayers, who was ex-Royal Navy, always called you by your surname. 'Matchett,' he said, 'I really like your work but I'm a bit worried that you've never worked for a newspaper.' They usually recruited from the weekly papers. In those days two hundred thousand copies of the *Belfast Telegraph* were sold every night and they reckoned that three people (mum, dad and one other member of the family) read each copy. So they claimed a readership of six hundred thousand, which is incredible. Companies paid as much for a full-page ad in the *Telegraph* as they paid for a television ad.

They offered me the job of staff photographer, with a six-month trial period. Some colleagues from the engineering company told me it was too big a risk; others told me I'd be an alcoholic in six months. However I took the job and have no regrets at all. Can you imagine waking up every day and looking forward to going into work to see what they had for you?

I stayed there for ten years, until I was approached by Mirror Group Newspapers. They had opened a state-of-the-art printing press in West Belfast and were printing in colour every day. They were interested in me because I had experience in colour photography. The picture editor invited me to join him for dinner. I brought a lot of my work – especially the colour images, including many record sleeves that I had shot – and by the end of the evening he'd offered me the job. It was a difficult decision to leave the *Telegraph* but in the end I went for it – to be working for a national paper was just unbelievable. My salary doubled immediately.

The Mirror Group were great employers in those days. In time, they offered all their journalists and photographers who were based in Belfast a sabbatical month, saying, 'Quite frankly, we don't know how you stick it over there.'

Shooting the Darkness

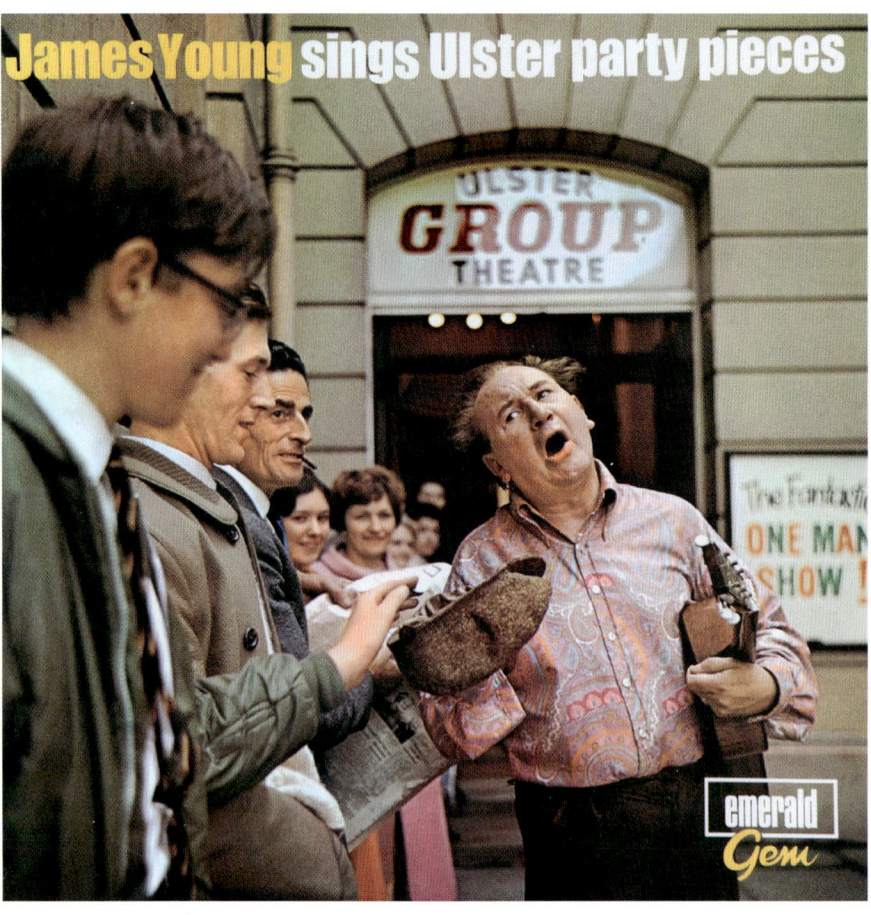

Two of the record sleeves that helped me to get the job at the *Daily Mirror*, one for James Young and the other for Gloria Hunniford. I had shot a lot of them – for the big twelve-inch vinyls – using the Rolleiflex camera, which was square format, six-by-six centimetres. The colour transparencies were what they wanted in those days, and I had worked out a way of being sure that they were all absolutely spot on for the publisher, using a flash meter bought in the USA to measure the flash very accurately and so on. I found I was getting work for all four companies that were producing records – they all watched what the others were doing and spotted my byline on the covers. James Young did his best to raise a laugh at the Group Theatre in Belfast. His last line at every curtain call was 'Will ye stop fightin'!'

Stanley Matchett

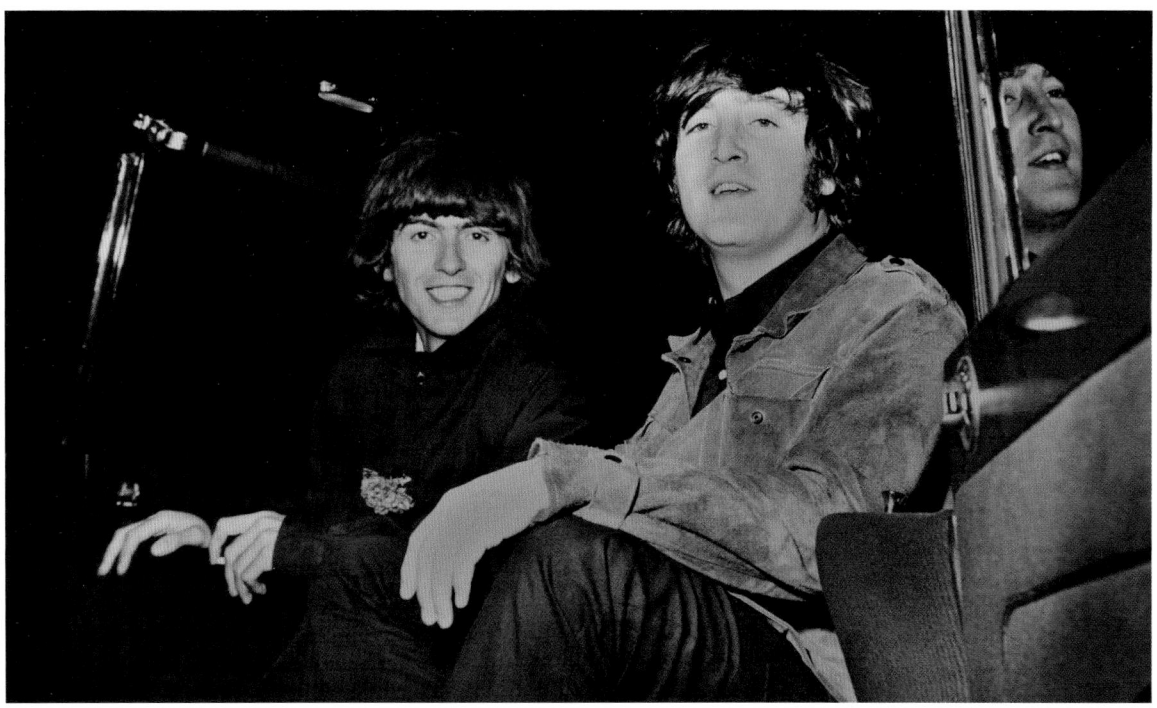

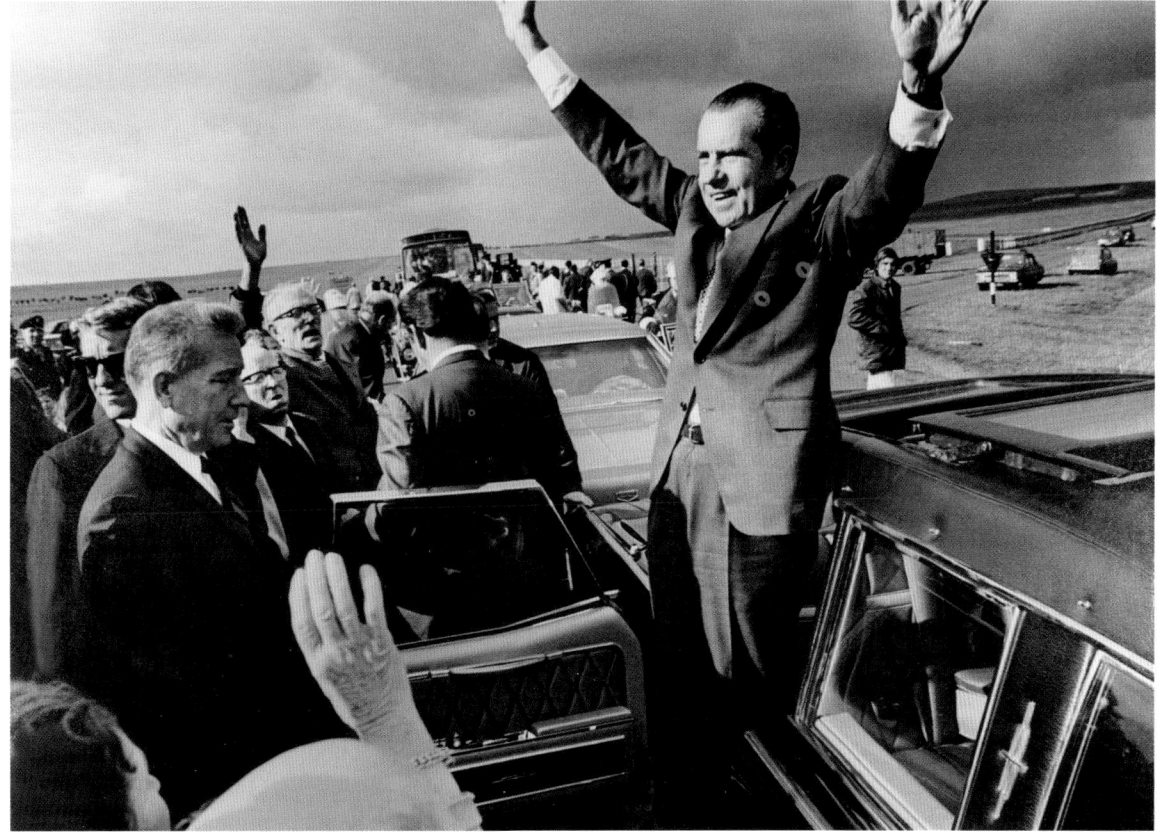

In the pre-Troubles days, all the big stars visited Belfast, including The Beatles in 1963.

I was thrown in at the deep end when US President Richard Milhous Nixon visited Ireland in October 1970, just a week after I started at the *Mirror*. It was no bad thing because I got used to working with the CIA and all the rest of it, and I loved the buzz. Little did I know I would go on to photograph four more American presidents.

Shooting the Darkness

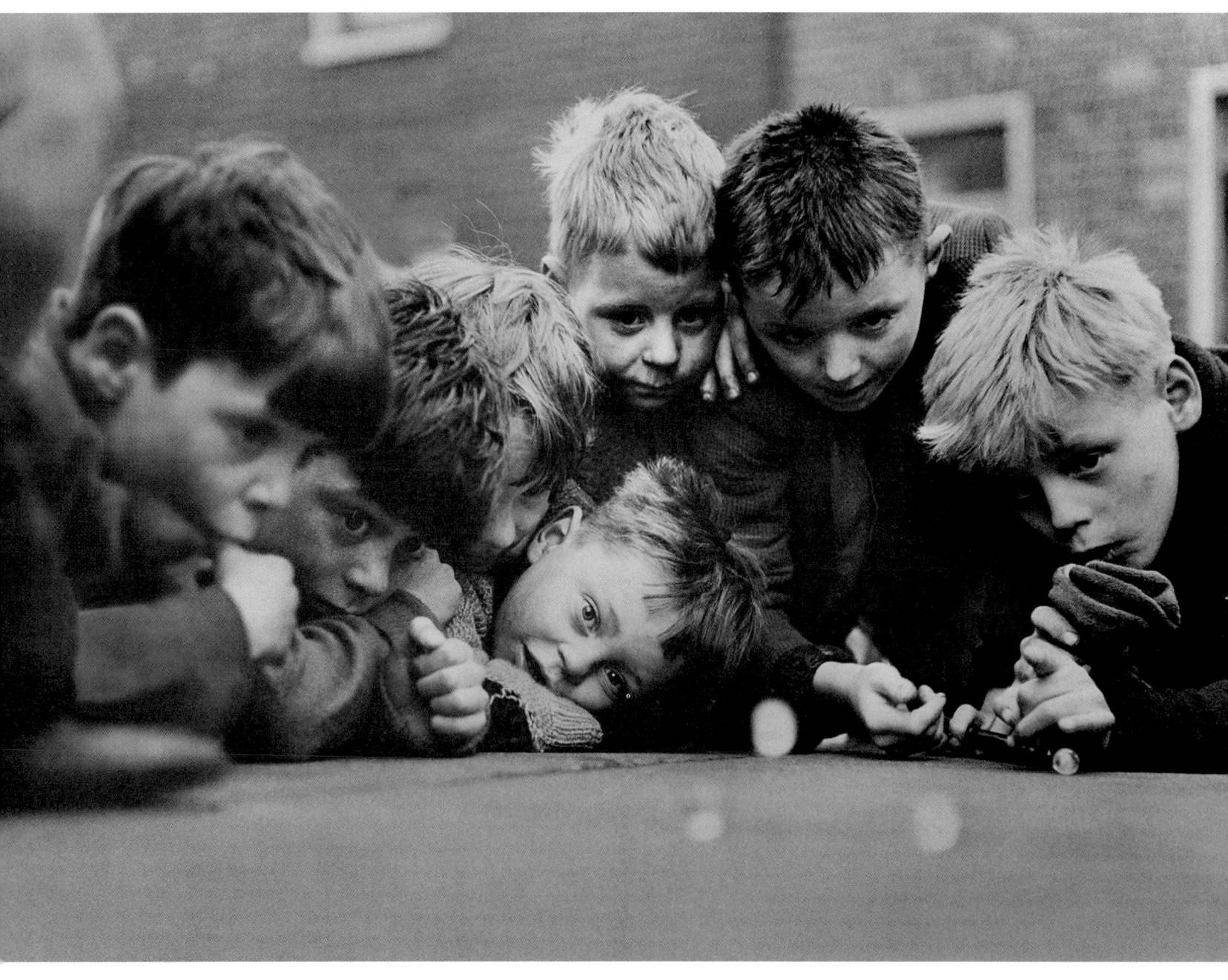

Boys playing a game of marbles on the
Shankill Road in Belfast in the 1960s.

Stanley Matchett

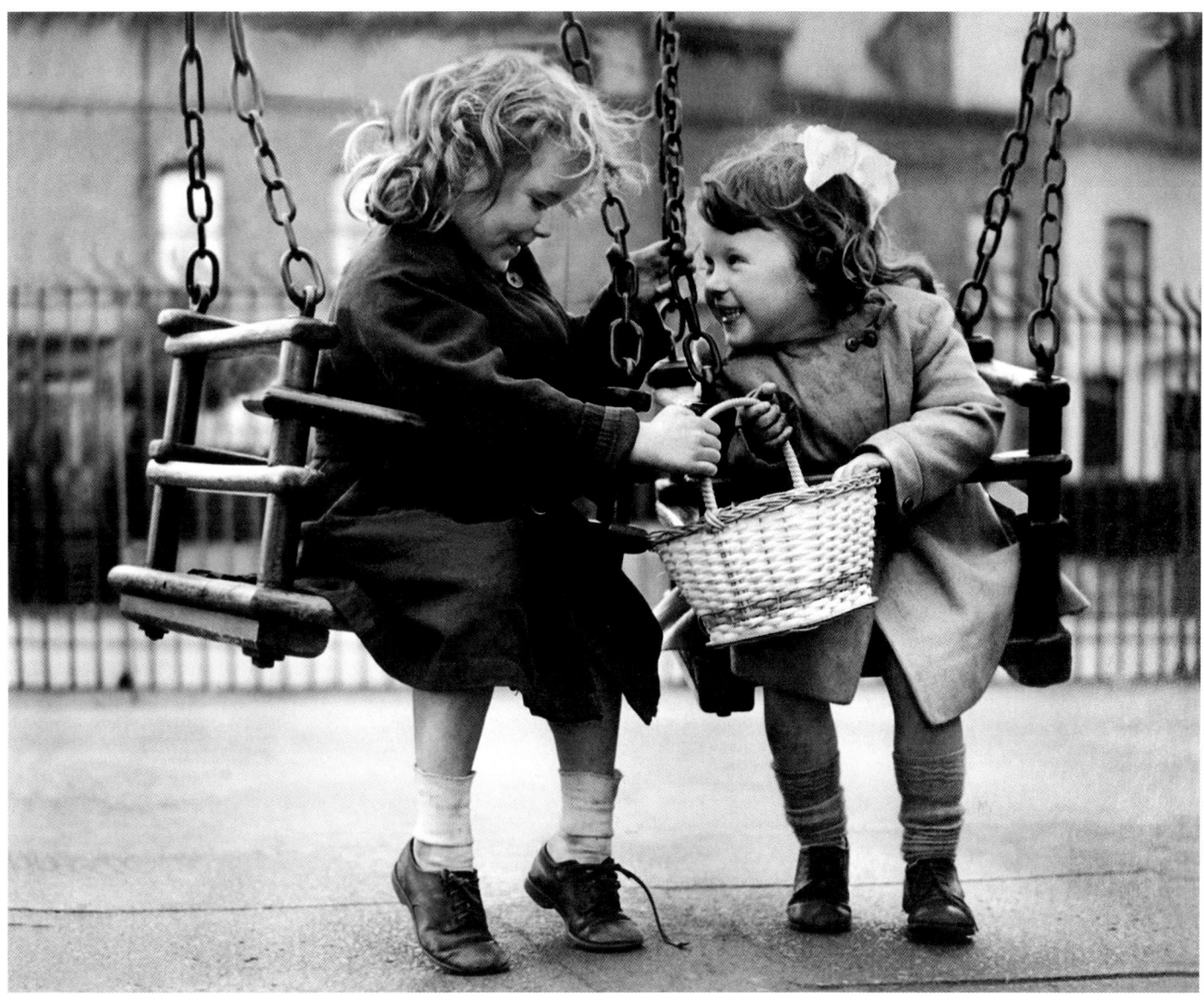

Two little girls on swings near Clifton Street in Belfast in the 1960s. At that time, none of us could have imagined how much life in the city would change over the next decades.

Shooting the Darkness

I took this photograph of a boy and girl guarding their street on the Crumlin Road in Belfast in August 1969, although I still think it looks as though it could have been taken in the fifties.

Years later, it was in an exhibition of photographs from the Troubles. The poet Michael Longley was at the opening and he told me that he thought it was the best picture in the show. As we were looking at it together, I heard a group of women nearby say, 'I wonder where they are now.' That made me wonder the same thing, and so I got in touch with a colleague from the *Belfast Telegraph*, Eddie McIlwaine, to ask if he could help me to find them by running a 'where are they now?' story. And, thanks to the story, we found them both and heard how life had gone for them since the time the photograph was taken. That was quite an experience.

Stanley Matchett

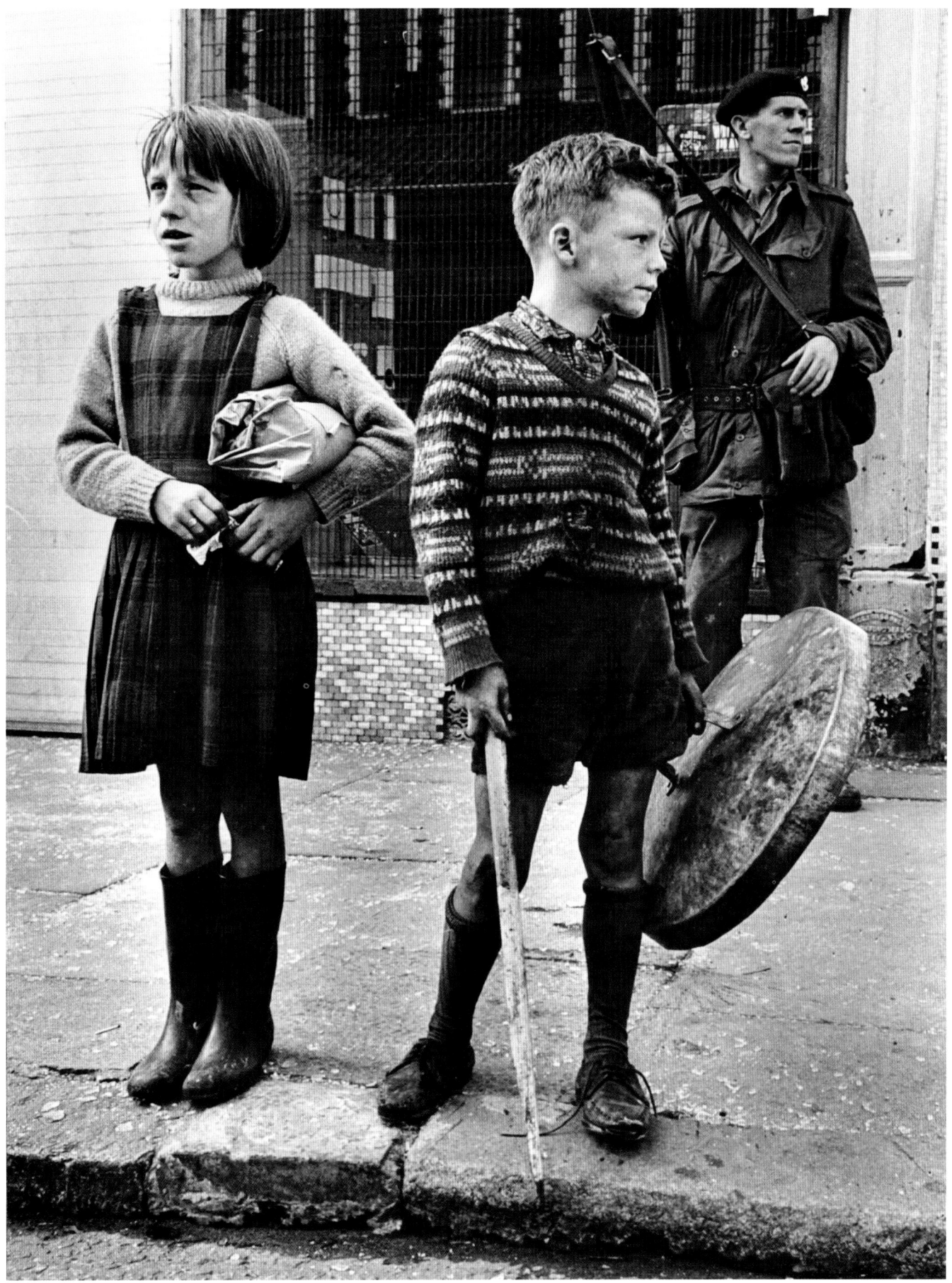

Shooting the Darkness

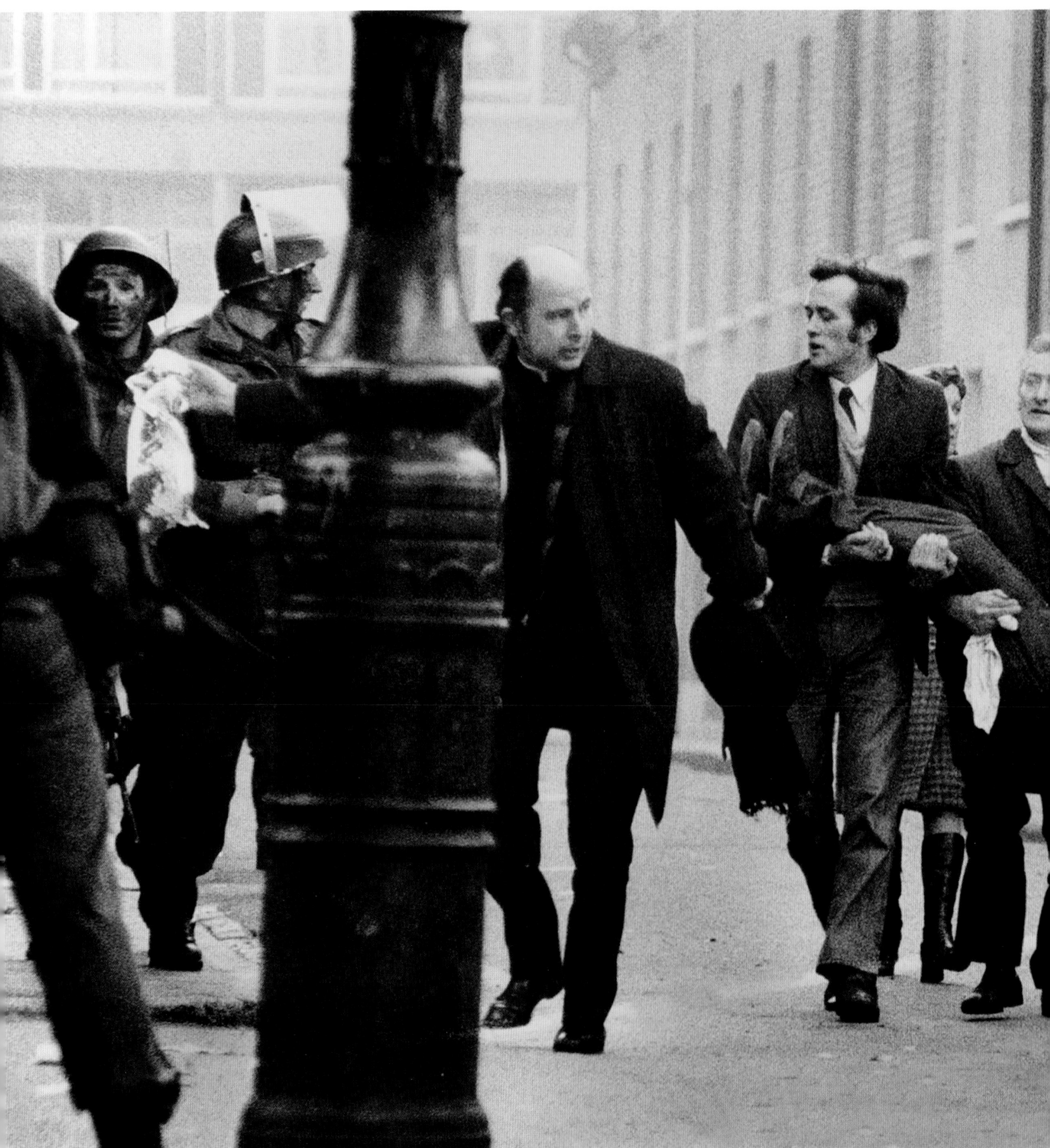

Stanley Matchett

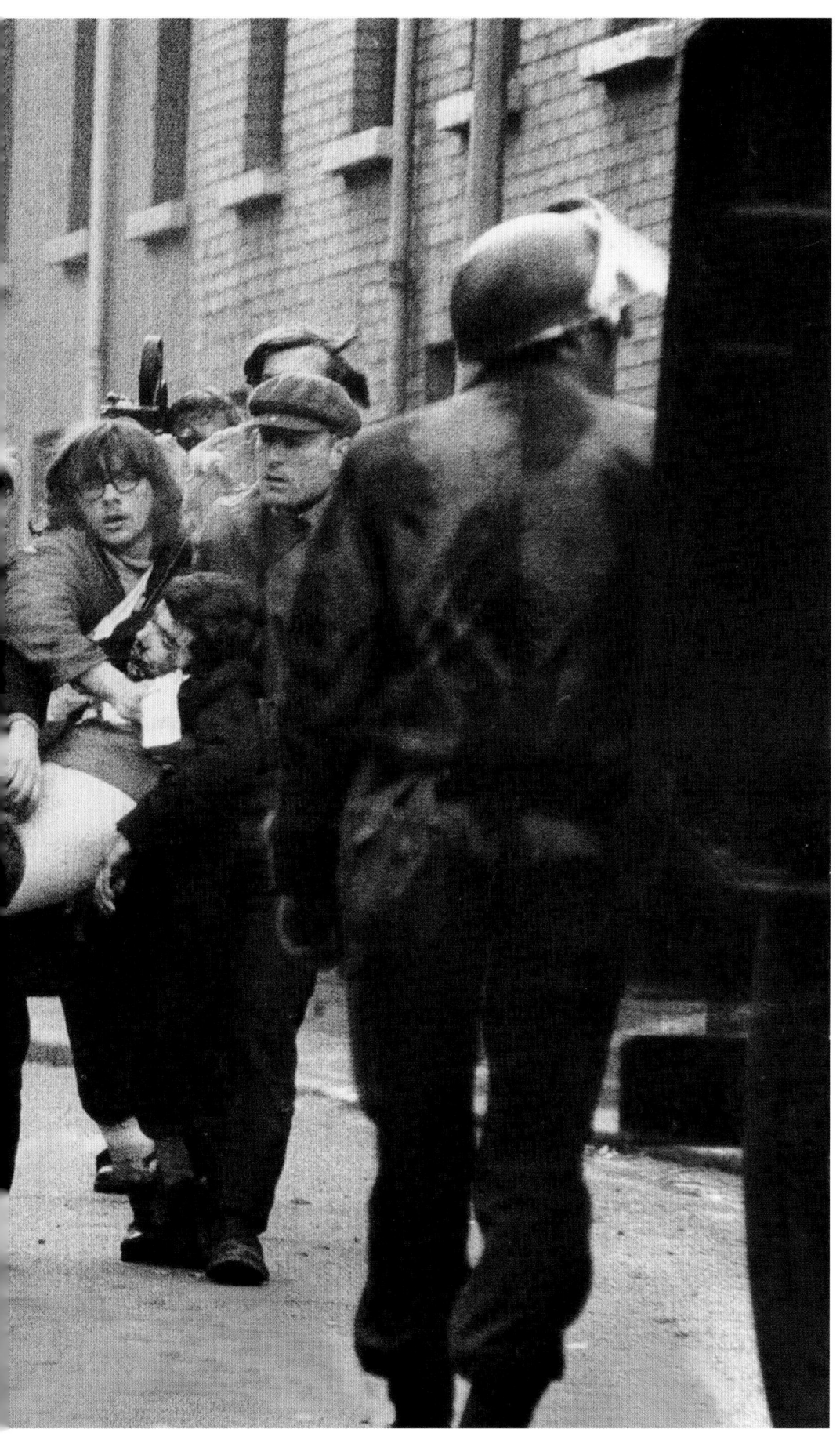

Thirteen people were killed when British paratroopers fired on a civil rights march in Londonderry on Sunday, 30 January 1972. Another man died of his injuries four months later. The day became known as Bloody Sunday.

In this photograph, Father Edward Daly leads the men carrying the body of Jackie Duddy (17). The image was described as the 'iconic image of Bloody Sunday' by *The Sunday Times*.

Shooting the Darkness

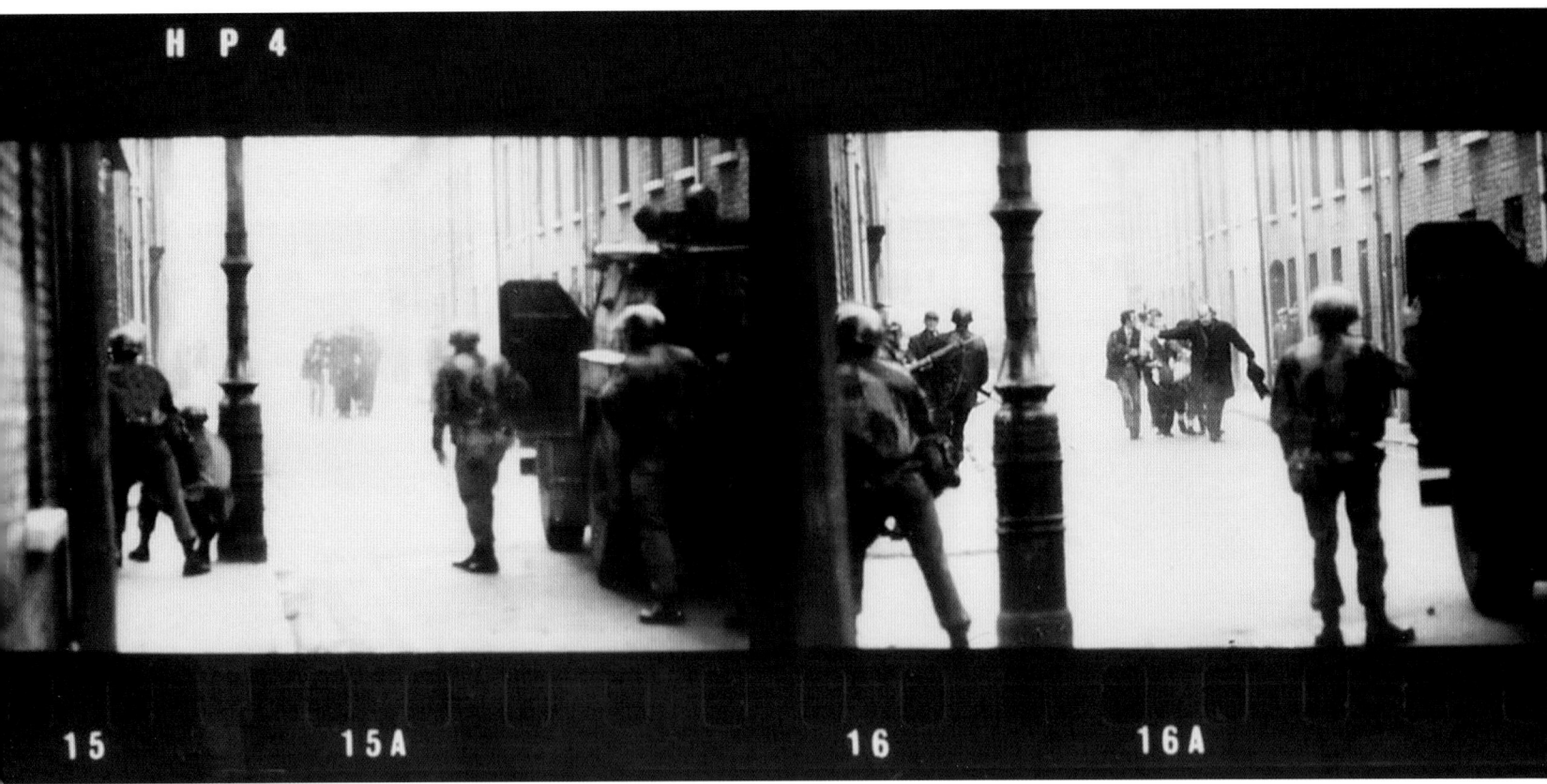

It was a Sunday morning and a beautiful day – blue skies, sunshine, a lovely day for a winter drive to Derry from Belfast. I expected to be home at half eight that evening, and I ended up staying for three weeks.

Chamberlain Street is a long narrow street. We were at the end of it and I think it was probably about 3.30 in the afternoon. At that time of year, the light is starting to go and there was a mist coming down after the clear-blue-sky day. We spotted this group coming down the street towards the end of Chamberlain Street – there seemed to be a film cameraman in the middle and other people carrying someone.

I have shot after shot after shot of them getting closer. When they got up really close, it became clear that they were carrying the body of a man, who we later learned was seventeen-year-old Jackie Duddy – just a youngster. It was Bishop Daly, or Father Daly as he was then, who was waving the bloodstained handkerchief, and the body was being carried by people who were in the march. Initially I thought that it was a foreign film crew but I was told afterwards that it wasn't. It was almost like stills from a movie, just frame after frame after frame as they got closer and closer.

Then they set the body on the ground and Father Edward Daly administered the Last Rites.

Stanley Matchett

Shooting the Darkness

The thing I remember was the total silence afterwards. You could have heard a pin drop. People were in shock; they were numb. You can see it in the picture I have of a medic holding his head in disbelief.

Stanley Matchett

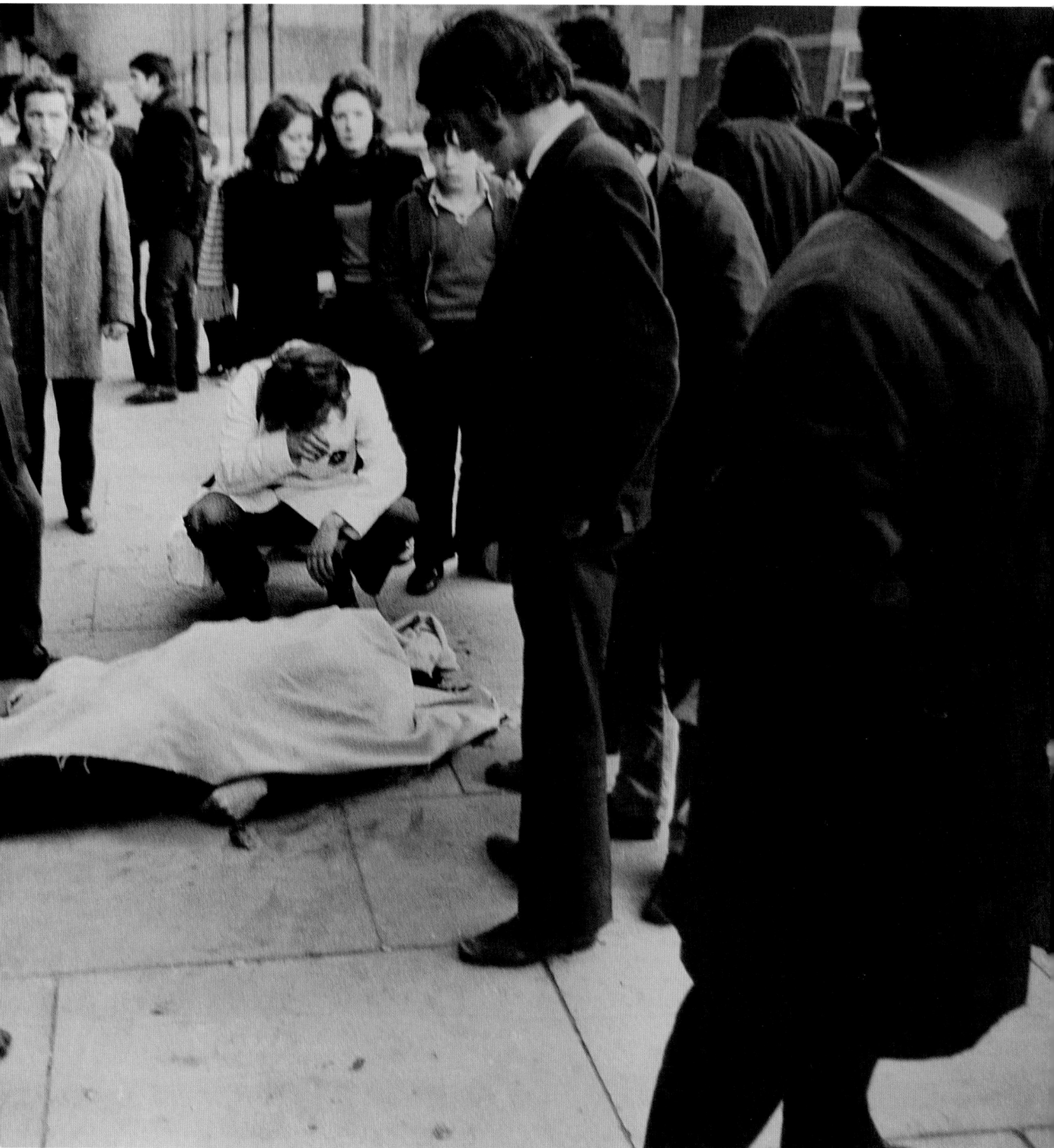

Shooting the Darkness

The worst time of the Troubles was 1972. That year, after each atrocity, we all thought, this is the one that will finish it. We had no idea of what was to come.

On 20 March 1972, less than two months after Bloody Sunday, there was the first retaliation. I was sitting at my desk when I heard an explosion. I said, 'God, that's a bomb.' The camera was always sitting on the desk with a fresh roll of film in it so I grabbed it and ran down to be confronted by absolute carnage. Crying. Women crying, policemen running to help.

The IRA had planted a 200lb car bomb in Donegall Street in Belfast city centre. Seven people died and 148 were injured. After that, every time I walked past a car, I wondered if it was going to blow up. That was frightening stuff.

In this picture, a paratrooper is comforting a young girl who was seriously injured in the explosion. She was a Czechoslovakian student at the art college; she recovered from her injuries and now lives in Canada.

Stanley Matchett

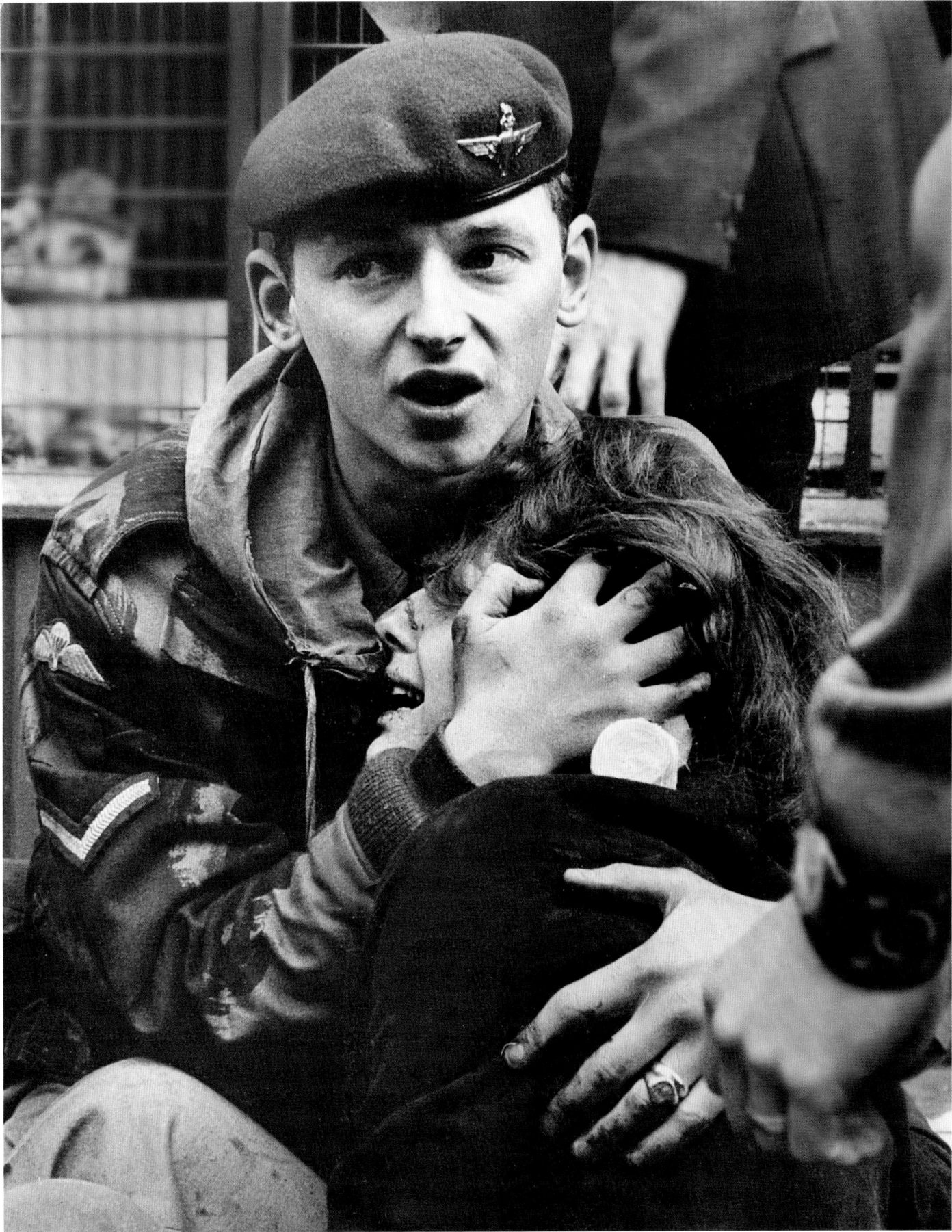

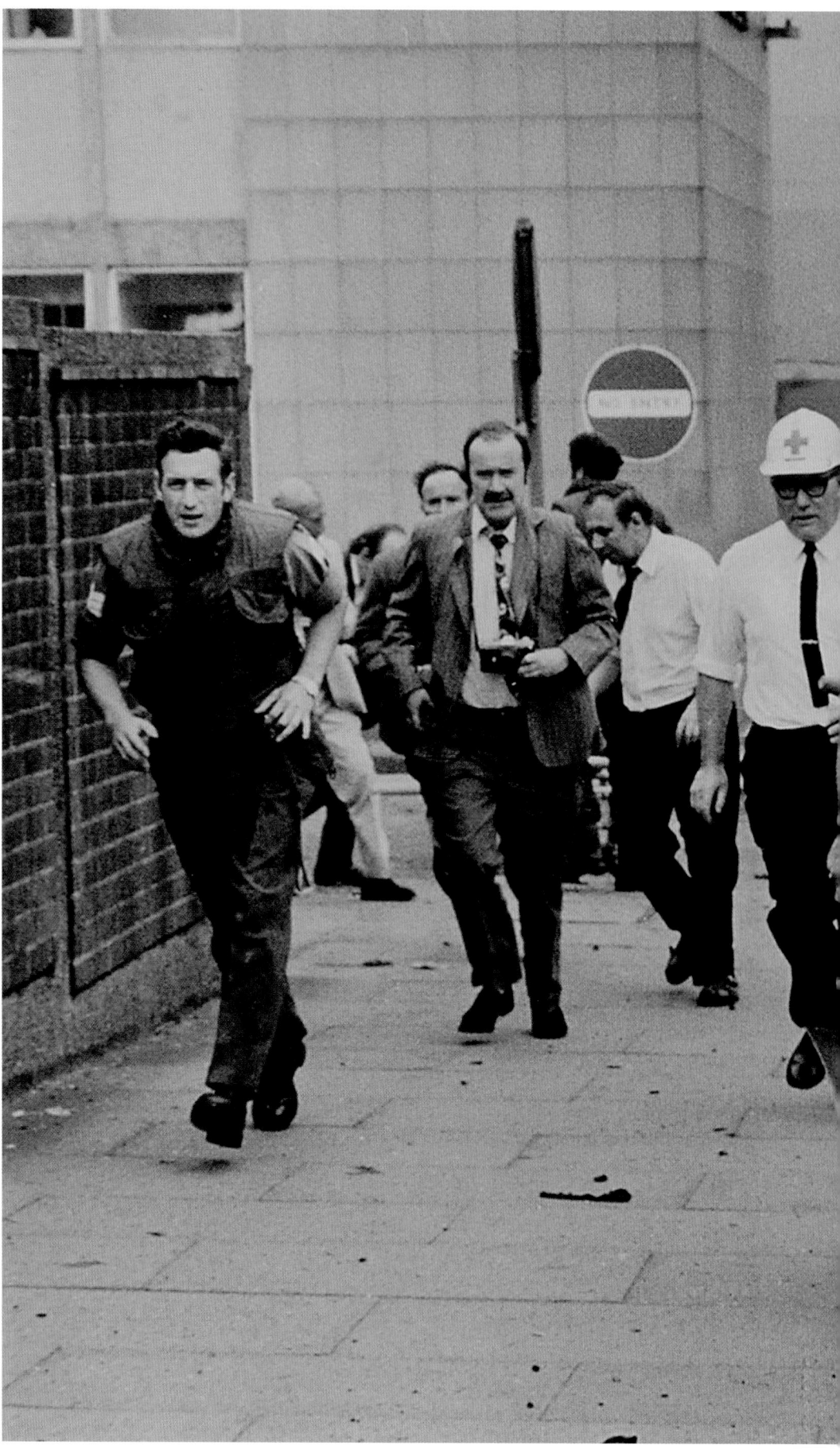

Terror in Oxford Street on Friday 21 July 1972, as at least twenty bombs exploded at various locations across Belfast. The day became known as Bloody Friday. People were running everywhere, not knowing whether or not they were running into the path of another bomb. In this photograph, *News Letter* photographer Eddie Harvey (with camera) runs to safety when a bomb explodes in Oxford Street Bus Station. A total of 9 people died as a result of the attacks and 130 were injured.

Stanley Matchett

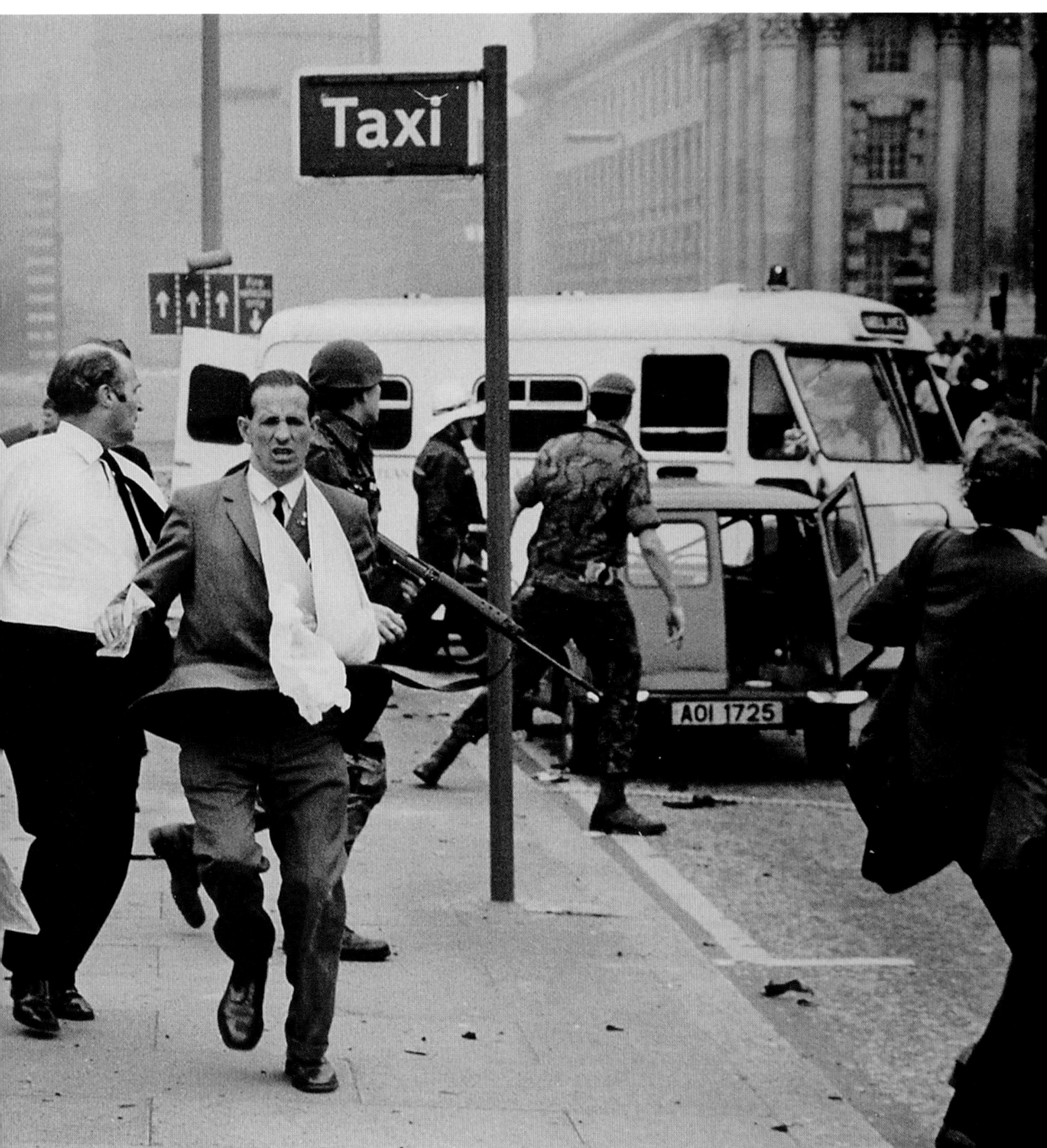

Shooting the Darkness

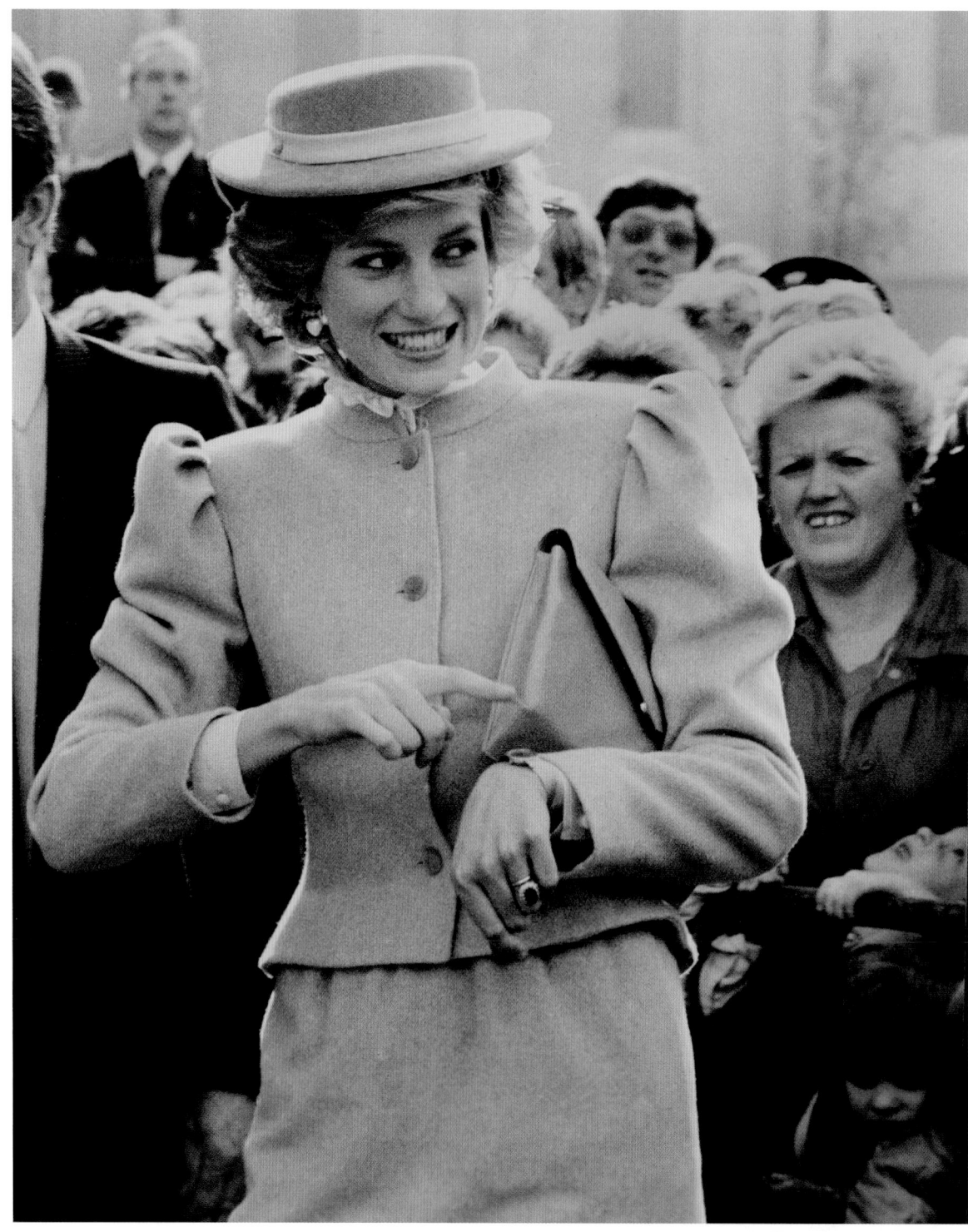

Monday 12 October 1985 saw the first official engagement for Princess Diana in Northern Ireland. At that time our offices were in Mark Royal House in Belfast city centre. There had been such extensive security preparations beforehand that we knew someone very, very important was coming, but we only found out that morning who it was going to be. I went up to the roof of the building to see what was happening, and saw the RUC marksmen in position. Luckily the officer in this picture had an interest in photography – he saw my camera and we had a bit of a chat. I came back up with coffees for him and his colleague, and then later, as soon as I saw the official cars coming, I went up again and got the picture. It was used at full-page size in *Life* magazine.

Stanley Matchett

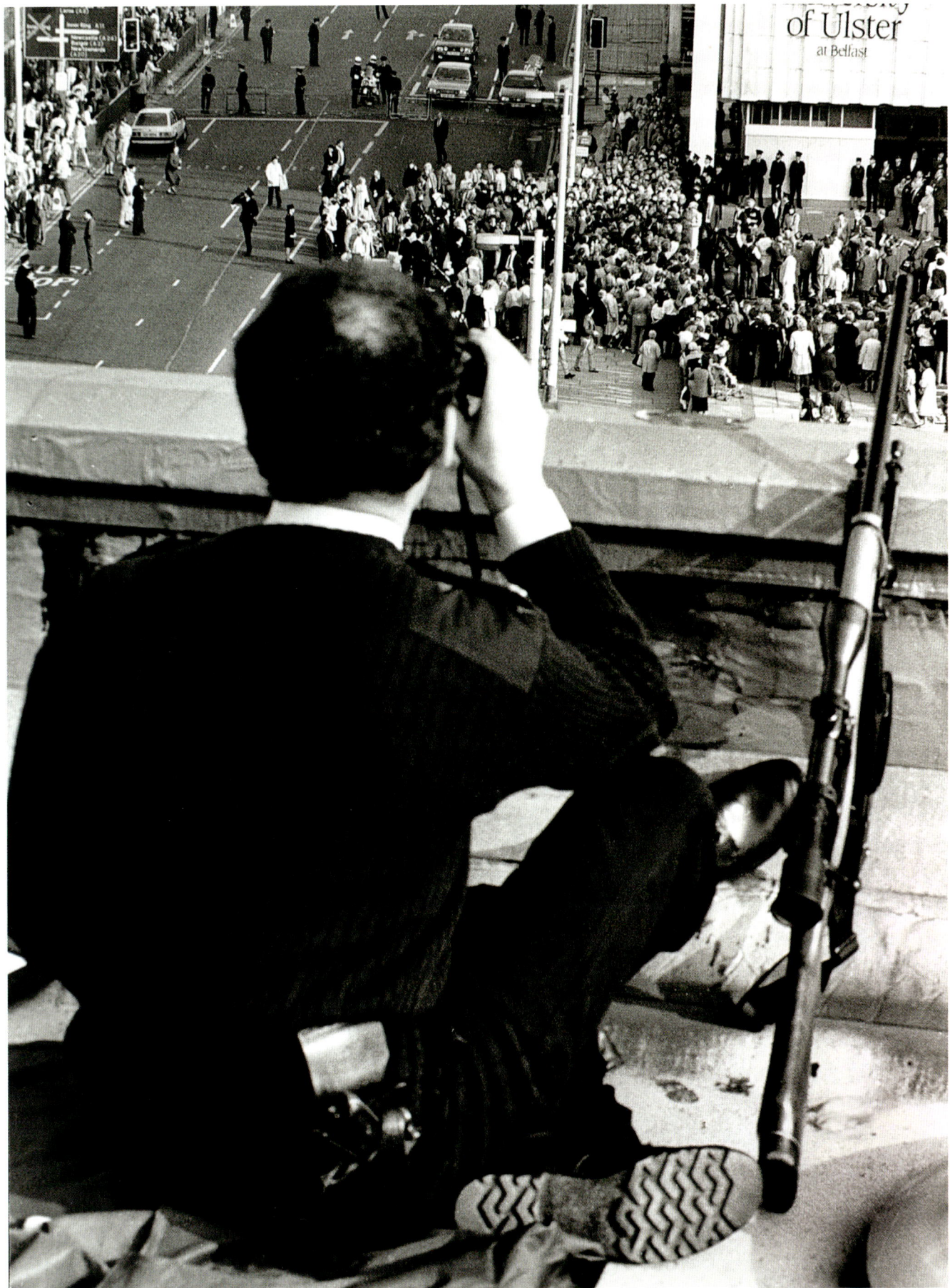

'Our job was to be right in the thick of it'
Trevor Dickson

In July 1963, when I was fifteen, I started in the *Belfast Telegraph* as a copy boy. I found out later that a fair percentage of the journalists and photographers had started that way. After a couple of weeks, I was assigned to the subeditor's department. The job consisted mainly of running errands within the office for the subs department. The chief sub at the paper knew that I wanted to be a photographer. He had a word with the picture editor – there were no openings at that time but he told me that, if there was an opening in the darkroom, I would be in line for it. The only problem was that I could have waited six months or six years.

So when a job came up with a wedding and portrait photographer in Lisburn, I felt that I should take it. It led to another couple of jobs with photographers doing similar work before I was offered two nights a week with a new weekly paper called *Cityweek*, published by the Morton Group. After about two months, they offered me a full-time job as a trainee in 1965. *Cityweek* covered everything in both communities: wedding anniversaries, pigeon clubs, darts clubs, birthday parties, all sports. Some nights you could easily have done fifteen jobs; the average would have been seven or eight markings. The city was thriving. The diary was always bunged, and the brief was to get as many people as possible into each photograph, on the basis that more people in the paper meant more sales. Nothing beats a good grounding working on a weekly paper. I think it sets you up for life, really.

The early signs of trouble in Northern Ireland meant a complete change for us. The first riots I remember went on in the Falls Road and the Shankill, and then spread to other areas like Ballymurphy and Londonderry. To begin with, we were so weary because it was so new to us and there was so much work, but then it was just like everything else in life: we got used to it.

Shooting the Darkness

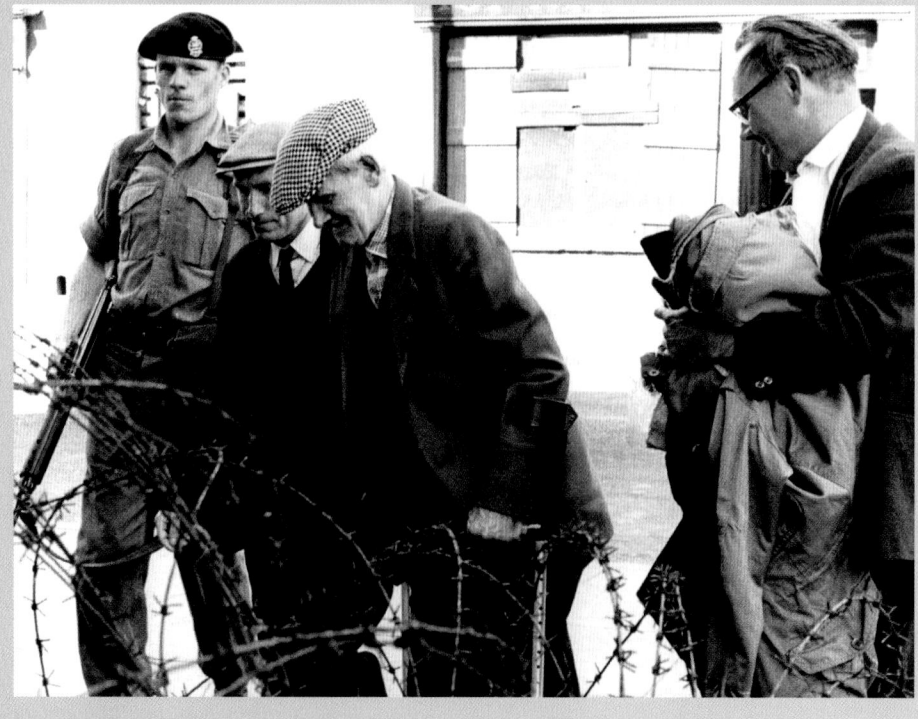

A pensioner who lost his home in rioting the night before is escorted into temporary accommodation in Divis Tower, 1969.

Trevor Dickson

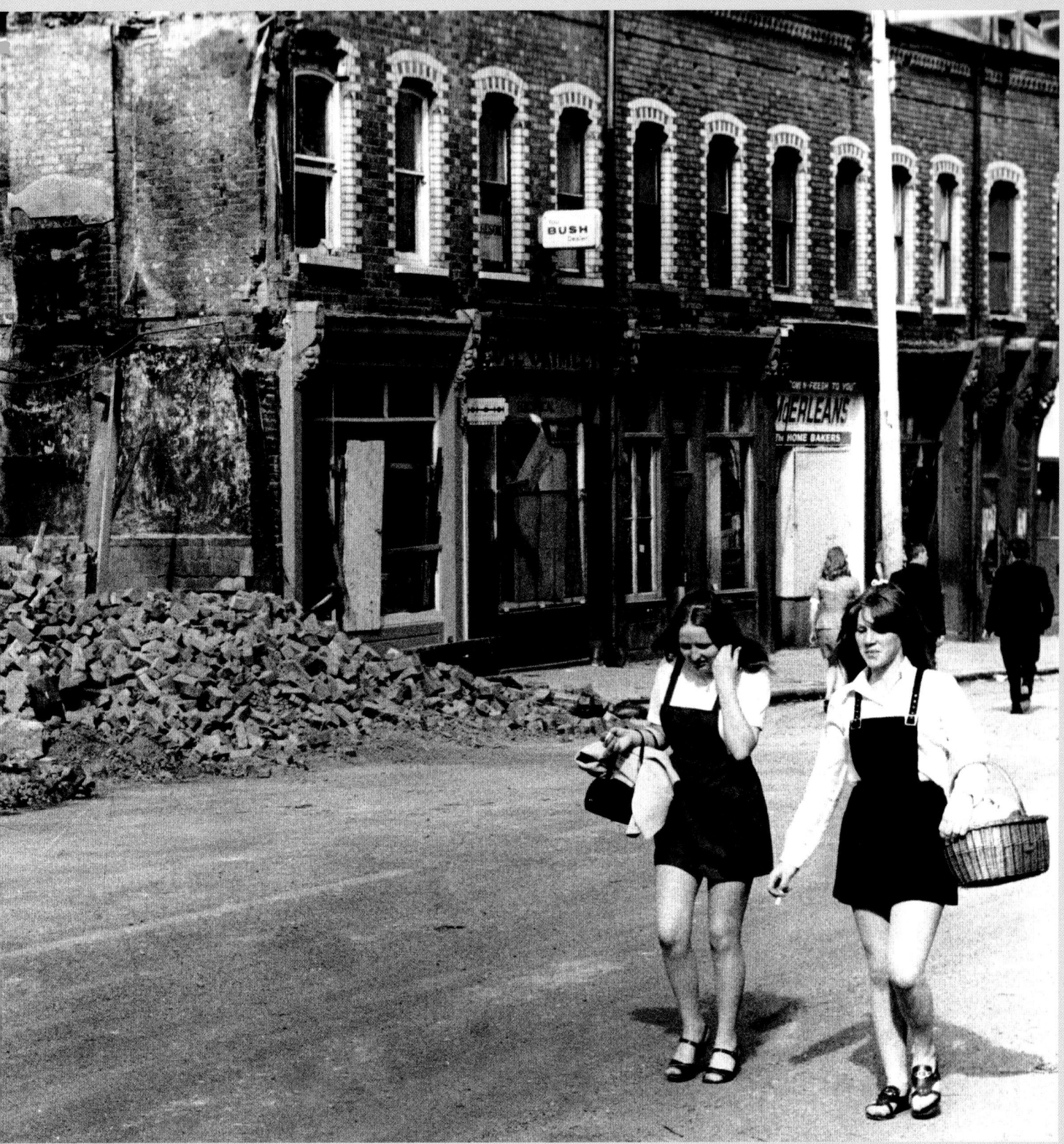

Two young women walk past the aftermath of the previous night's rioting on Divis Street in 1969.

Shooting the Darkness

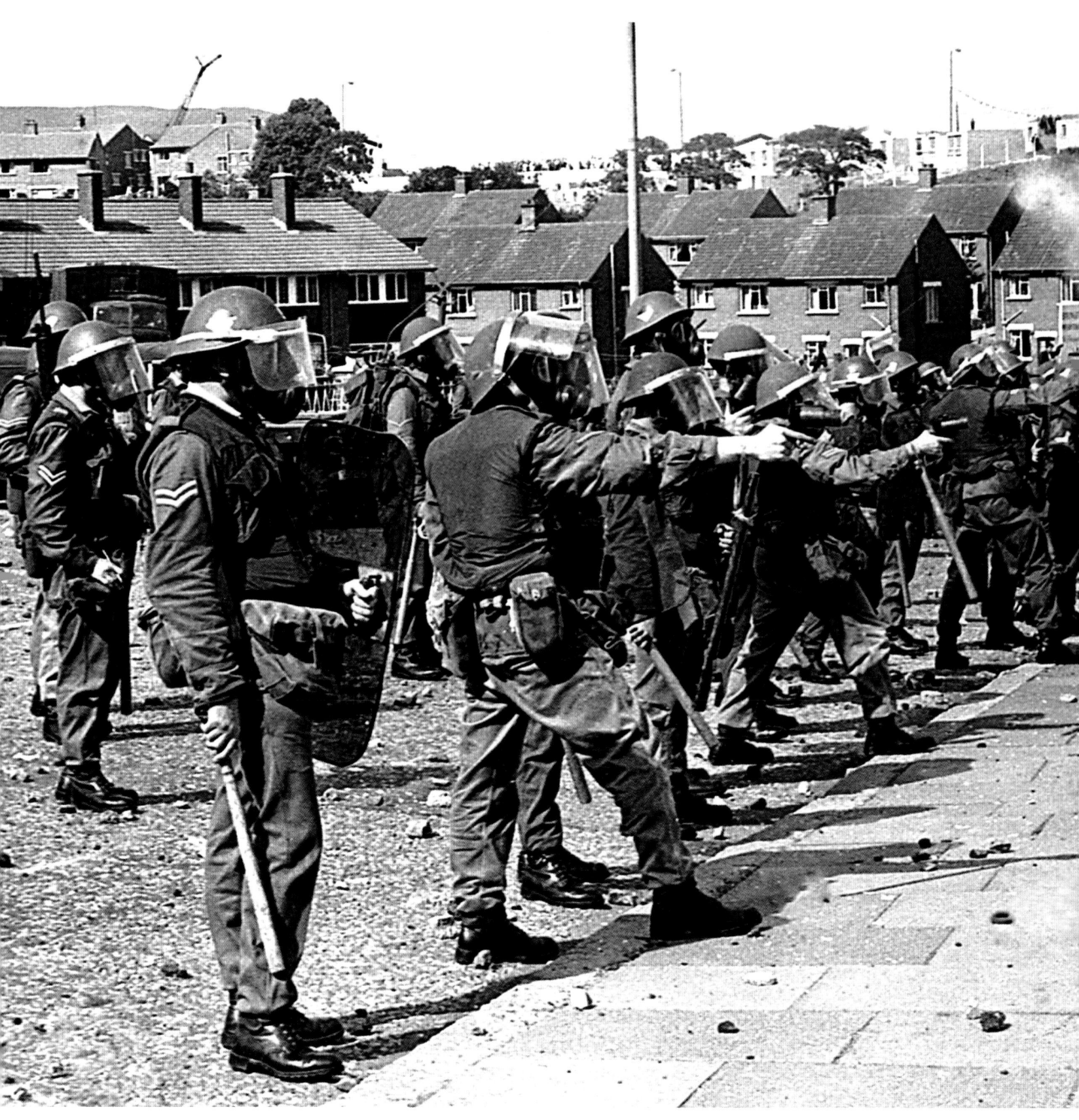

Trevor Dickson

This picture was taken by my good friend and colleague Brian McMullan during one of 1970's big riots in Ballymurphy. The army were firing tear gas and rubber bullets, and I stood with them to get a good photograph of the riot. As I walked back to Brian, I said, 'I hope you've taken a picture of that.' I offered to take one of him in the same position but he replied, 'Do you think I'm stupid?'

Shooting the Darkness

There was often trouble at the annual Whiterock Orange parade, especially at the point when it came on to the Springfield Road from Mayo Street. As the parade made the right turn into Springfield Road to head up to Whiterock Orange Hall, there were always protestors.

In 1970, my colleague Brian McMullan and I were marked to cover the parade. We knew just what was going to happen that Saturday, so we stood in the best place. The next thing was, all these rioters appeared out of the streets below and came up throwing stones and bottles.

There were two full pages of pictures from the riot in Monday morning's edition of the *News Letter*. All of them were mine, bar two, but there were no bylines on them – some things you didn't want your name attached to.

Monday was my day off, so I wasn't back in the office until Tuesday. The receptionist called up to say that there were two policemen to see me. They were both detectives and they told me that they'd been in to the office on Monday to get the negatives of the pictures of the riot and had got blow-ups done of all of them. Massive, easily A2 size. This meant they could use them to identify a whole lot of the people involved.

They said they knew that I'd taken the pictures; I said no.

A few weeks passed and they came back in to see me to tell me they had the men involved appearing in court, and that I should appear as a witness. I didn't go. Then the same thing happened again. The third time, the detectives came back again to give me the date, and to tell me they would arrest me unless I went. They promised me a disguise and assured me that all my details would be withheld, and that I would just have to say that I'd taken the photographs, nothing else.

They gave me a wig and painted a black moustache on me. I was called and, once I was in the witness box, my full name and address were announced in court. I immediately said that I had come under duress – that this was the third time I'd been asked to come, and that I'd have been arrested for contempt of court if I hadn't. I said to the men in the dock that I had only been doing my job and that I'd been told none of my details would be given out, then I just walked out. I was called in next by the defence barrister and said the same things again.

It was an anxious few months after that.

Trevor Dickson

Shooting the Darkness

In January 1971 a call came into the office and I wasn't going to answer it because I was ready to go home. But I lifted the phone and it was a contact from the old Official IRA. He said that a reporter and I should go out to the Albert Bar, at the junction of Albert Street and the Falls Road. When we got there, this chap asked us if we'd like a drink.

So, a bottle of stout each and the next thing a man came in and nodded to the chap that was with us for us to come out. When we got outside they were just finishing tying a boy to one of the big lamp standards. They poured a bucket of tar over him, then a pillowcase of feathers, and then put a plaque around his neck saying why it was being done. Then another man appeared and they did the same thing to him.

I took one shot of each and was just ready to leave when I heard this shouting. It was a priest coming down the road on his bicycle. He came charging across the road, saying, 'Don't you take pictures of those poor fellas,' and tried to grab the camera off me. But the Official IRA boyos, they got hold of him, told him to move on.

The picture on the right was the front page of the *Sunday News* the next day and on the Monday it was on front pages throughout the world. To the best of my knowledge, my pictures were the first press photographs ever taken of tarring and feathering.

Trevor Dickson

I took this picture at midnight or one in the morning on the Crumlin Road during riots in Ardoyne. The rioters were throwing everything at the soldiers. I caught the bullet leaving the soldier's gun – just a half a second's exposure handheld to capture it. There was complete darkness – the authorities kept the street lights out in the vicinity of trouble so that it was harder for the rioters to make out the security forces.

I always found that when I got to the situation I would think, this is dicey, for a moment or two, and then I was working and got on with it. And then afterwards I might have thought, that wasn't great, relieved to be out of it.

Nine out of ten times, most of us photographers just went in. Part of our job was to be right in the thick of it and we would have been targets sometimes. Sometimes people asked what paper I was from – I usually just said that I was from the *News Letter* and that I was doing my job. Once, I knew that if I'd said where I was from I would have been in danger. It was an anti-internment march outside Oldpark Police Station, 10 or 11 o'clock one night. I'd wondered whether I should even go or not.

When I arrived, there was no other press man there. I just watched and there were a couple of hundred women. I took a picture of women holding placards. The next thing was, a woman asked what paper I was from. I can't remember what paper I said, but I didn't say the *News Letter*. I knew that if I'd told the truth they would have had me and the camera.

The following Saturday there was another protest in Hamill Street, off Divis Street. There were at least a thousand women at it, a few men too. I noticed a pillar box and got on top of it. I'd taken my shot and was just about to get down when Olwyn James from the *Belfast Telegraph* asked me to take a couple for him. Then Brendan McCann from the *Irish Independent* asked the same. Just as I was handing Brendan his camera back, I heard a voice say, 'There's that skinny Paisleyite bastard from the *News Letter* who was at the other march.' They assumed that because of the paper that I worked for.

As soon as that was said, the women started to come for me. There was a couple of men around who saw what was happening and walked me and the other two photographers to the edge of the crowd. Then they said, 'Right boys, run,' which we did. Olwyn and I only stopped when we got all the way into the city centre. He bought me a coffee in the Wimpy to make up for the fact that I'd only been up on the pillar box for a longer time to do him and Brendan a favour.

Trevor Dickson

Shooting the Darkness

In 1972, a man came into the *News Letter* office to speak to me. He said, 'Would you be all right going to take pictures of armed UVF men?' He assured me that I would be 100 per cent safe and that I would be the first person to get the chance to take this kind of picture. The only thing was that I would be picked up and blindfolded until I got to the place where I was to take the photographs, and then blindfolded again for the journey back.

Once I'd agreed, they suggested a Sunday. I was down to work that day anyway. When I arrived at the office on the appointed day, I said to the news editor that I wouldn't be around until teatime, so he'd need to get a freelance to cover if there was a major incident. I couldn't tell anyone what I was doing but reassured him it would be some scoop if the pictures came off.

I went to the place they'd told me to go to be collected, about a quarter of a mile from the *News Letter* building. Next thing, two cars pulled up and two guys got out and asked me to go with them. I was put into the back of the car, sitting between two men, and they told me they were going to put a hood on me, but not to worry for my safety.

After about an hour's driving, the car stopped and they helped me out and after a minute of walking, we were suddenly on grass. Then after five or six minutes, they took off the hood and gave me some time to recover and for my eyes to adjust. I had just a few minutes to shoot the photographs before the hood went on again and I was returned to the meeting point.

The *News Letter* published the photographs without any byline.

Trevor Dickson

Shooting the Darkness

Trevor Dickson

The aftermath of a 1,000lb bomb that detonated in Belfast city centre, 28 March 1974.

Shooting the Darkness

On 28 February 1985, Trevor Harkness, who was a member of the UDR and a married father of five, was killed by an IRA bomb near Pomeroy in County Tyrone. On the same day, the IRA killed nine RUC officers in an attack on Newry Police Station. That meant that there was a number of funerals taking place on one day. I was marked to go to Trevor Harkness's and I was the only photographer there, although there was also a television camera crew.

As the cortège was leaving the home, I took a photograph of his wife, Phyllis Harkness, and just as I was winding on, her hand went up to hold on to her husband's coffin. It was only for a split second but I just caught it – no chance for a second picture because her hand was already down.

All the funerals that had taken place that day were spread over a page the following morning, but that one was on the front page and won picture of the year.

My heart just went out to her – a very young widow with five children.

I learned later that Phyllis Harkness died when she was just forty-four. Her family believe that her early death was caused, in part, by the tragic loss of her husband.

Trevor Dickson

Elizabeth Rush kisses the cap of her husband, Samuel, who was shot dead at the wheel of his bus while driving through a gun battle at Albert Bridge in Belfast in June 1973.

Shooting the Darkness

The police station on the Lisburn Road in Belfast was bombed on 16 December 1986. I went up the next morning to get a picture. I noticed that the houses across the road had been badly damaged and spotted a mirror on the lawn of one of them. It amazed me that it hadn't been damaged in the blast, and an idea came into my head right away. I propped the mirror against what was left of their garden pillar.

I always tried to make something a little bit different, rather than the usual point and shoot.

I was coming up the Ormeau Road to cover a charity cheque presentation on 5 February 1992. I saw a police Land Rover parked before the Ormeau Bridge, and I had noticed three or four people outside Sean Graham, the bookies. And I just thought something might have happened. I parked by the bridge and walked down. When I asked someone outside the bookies what had happened, she told me there had been a terrible shooting. I just hung on and the next thing the ambulances arrived and paramedics went in. This man, William McManus, died in the ambulance on the way to the hospital – one of five murdered in the UFF's attack; nine others were injured, one critically. This photograph was the front page of the *News Letter* the next day.

'We showed what was happening as honestly as we could'
Alan Lewis

I'd been interested in photography from a quite young age – my uncle encouraged that – so by the time I was studying at Queen's I was able to get a summer job in England working at holiday camps, taking pictures of people on the beach, junior Tarzans, all sorts. If the holidaymakers liked the picture, they could buy it. So I learned very quickly how to crop and frame pictures, get exposures right and make things tight. I brought that back with me.

One Saturday afternoon in Belfast in November 1971, I met an old friend of mine. He said he'd just started working at a photographic agency and, knowing what I'd done over the summer, asked if I would fancy a job. I went up and met Vic Patterson and he gave me the job straightaway. Vic was a very innovative guy – he was into technology and he had his own radio base station at his house in Eglantine Avenue. While I was chatting to him, word came in about a shooting up in West Belfast. He gave me a camera and away I went.

There was never a typical day but there was something happening every day and it was pretty much all hard news. There was enormous public interest in the events that we were covering and, for me, it was exciting. It was a buzz to get pictures published in the papers, both local and national. We were tailoring the jobs to the particular newspapers. So, with the likes of *The Times* and *Guardian*, we'd have a bit of licence to do arty stuff, which I liked, whereas with the tabloids, space was very valuable and there was a lot of advertising, so we were more constrained.

On 11 December 1971, just a month or so after I started with Vic, there was a no-warning IRA bomb at the Balmoral Furniture Company on the Shankill Road. We got a call about it. Back then you could listen in to security forces and ambulance frequencies, so we were able to determine very quickly where the bomb was. I hadn't been working that day but got a call to come in. By the time I got to the office my colleague Ciaran was back from the scene to start processing his film. I went back to the site of the bomb because I knew that there were still people missing and searches going on.

I positioned myself beside an ambulance at the side of the road so that I wasn't getting in the way. The search teams, the army, the police, civilians – everyone was scrambling through the rubble. A baby was then found in the wreckage and was carried out towards the ambulance. I was looking through the camera but I just froze; I couldn't take the picture. The baby wasn't covered and it was something I have never forgotten to this day. So I didn't take the picture and I was angry with myself for not doing it. I resolved to myself that if the same thing happened again, I would.

About half an hour later, I heard a commotion. The crowd parted again and an ambulance man came walking towards me. He was carrying another child, this time wrapped up in a blanket. And I got a picture of it that has become iconic over the years, and was used on the front page of virtually every national newspaper – in the north, south, UK and even further afield. When we processed the picture and sent it out, I actually thought that it might stop people from joining paramilitary organisations; that it might deter people if they saw the horror that I had just seen.

The two babies died in the blast. Two employees of the shop were also killed.

Years later, I was out doing a one-to-one photo session with David Ervine, a former UVF member and the leader of the Progressive Unionist Party. I told him my hopes for that photograph and he said that it had had the opposite effect. He said that my picture was one of the biggest recruiting sergeants that the paramilitaries ever had on the Shankill; that young men were queueing up to join the UVF and UDA when it was published. To hear that really distressed me. But Ervine said that the photograph had brought people like him into the paramilitary organisations. And that he had learned in time that politics was the way forward.

So, in a perverse way, it did have a positive effect, because the Troubles were never going to end straightaway. That was some comfort.

Alan Lewis

The single worst part of the job was going to the home of someone who'd been killed and asking a family member if you could borrow a photograph of the victim to be used in the newspapers and on television. This photograph was called a collect. It's not like today with social media, when people post photographs all the time. You had to go and knock a door and ask the question of whoever came to the door. Sometimes you were invited in for a cup of tea. Other times you were told in no uncertain terms where to go. Down the years it didn't get any easier, having to put yourself in that position when you're right in their face. It's personal.

Then on one occasion it was so personal it was unreal. We got word one morning in June 1973 that two bodies had been found up in the Ligoniel area of North Belfast. The name of the male victim was leaked quickly – he was Paddy Wilson, a nationalist politician and a founder member of the SDLP. Then the name of the woman he was with filtered through, and it was Irene Andrews.

Irene was a good friend of mine and I'd been to her house. I was asked to go and do a collect since I knew the family, but when I got there Mrs Andrews, Irene's mum, opened the door and said, 'Oh Alan, come on in, Irene's not home yet.' She didn't know. I'd just walked into a huge hole. I couldn't get out of the house quickly enough. The first thing I wanted to do was to get the word through to the police, to get a minister up to the house to let her know what had happened, and I wanted to make sure that no one else would come knocking on her door to deliver the news to her out of the blue. It took about another hour and a half for any official to come to the door. And in the meantime, I'd turned people away and told them that Irene's mother didn't know yet.

That was the worst. And I know other photographers who've been in similar circumstances, you know, where they've just blurted out the news when the family didn't already know. Thankfully social media means that we don't have to make those calls any more – that has taken a large weight off an awful lot of people's shoulders.

Alan Lewis

Shooting the Darkness

Alan Lewis

For a long time, I began to think that I'd almost lost my humanity. I was taking photographs and didn't seem to care what I'd seen, and that worried me. I was wondering what I was becoming. I didn't like it.

Then one Monday in 1974, I was coming out of a building in High Street when I heard an explosion, and about a minute later, fire engines and ambulances started arriving into High Street and going around to Bridge Street. So I ran up that way, and as I ran, I heard another explosion.

There had been two bombs at two cafes in Rosemary Street and I was on the scene very quickly. There were a lot of injured people sitting about, wandering around, crying, bleeding, and I was shooting pictures everywhere I could go, looking around me, on autopilot. There were three kids who'd been in the explosions sitting on the steps of the Masonic Hall. I took a couple of frames there and went straight back down to the darkroom. I processed the film and got it into the developer.

As the pictures were coming up, I stopped to look at what I had been taking. I saw the kids sitting there, on a day off school, caught up in a bomb through no fault of their own. I just started crying in the darkroom. Nobody saw me but I knew then that I was all right. I had been boxing stuff off – probably the only way to deal with it. I was relieved that I had had a release of emotion.

Then I got on with the work again, knowing that I hadn't lost the run of myself.

Shooting the Darkness

In January 1978, there was an IRA mortar bomb attack on Forkhill RUC Station in County Armagh. I drove there from Belfast with Milton Haworth, a *Daily Express* photographer. When we got to the site of the bomb, we met an RUC press officer. He told us that the IRA were constantly developing their mortar technology and that they had used a new type of mortar tube in the attack. We asked whether there'd be any chance of us photographing it once the army bomb disposal experts had cleared the area. We waited for about two hours and eventually we were taken around to a cul-de-sac from which the mortars had been launched – there were six tubes on the back of a lorry. We asked if we could get on to the lorry to take a picture of the tubes and the press officer said, 'I don't see why not.' That wouldn't happen now because of forensics. Using a wide-angle lens, we were able to get an image of the tubes with the station in the background – we thought that was going to be the picture that would signify this particular event. Plus it was a new mortar, so it was taking the story on a little bit.

Alan Lewis

We got our pictures and we jumped back down again. We'd got about a hundred yards around the corner when we heard a bang. The bomb disposal team had missed a booby-trap bomb wired to the ignition. So when the police turned the ignition on to drive the vehicle around to Armagh or wherever they were going to take it for further forensic work, the bomb exploded and destroyed the front of the lorry cab, injuring two policemen quite seriously. There was chaos. No one noticed us going around the perimeter. We used longer lenses to operate without causing any upset, trying to stay out of the way before someone noticed us and threw us out.

Because we were right on the border, the army had to use a helicopter to medevac the guys out. I remember thinking to myself that it was like Vietnam: the helicopters, the soldiers on the ground taking up sniper positions, the stretcher being rushed to the helicopter. I also remember thinking how lucky we had been. If the engine had been started when we were on the back of the lorry, God knows where we'd be now.

Our job was to show what was happening as honestly as we could. It was the only way we could do our job and be able to operate in and among both communities. Obviously there are pictures I've done that wouldn't be popular in nationalist areas, and others that wouldn't be well received in loyalist areas, but we were always fair.

Loyalists came to the party late in terms of PR, whereas Sinn Féin were very early adopters. If there was a riot on the Falls or in the Bogside, the nationalists would allow us to work in among their rioters. It then looked as though the other side, whether loyalists or army or police, were the aggressors. The loyalists just saw the end result of the media showing them as the attackers. If they'd used similar tactics at the time and allowed us in, they'd have had better PR too.

It was at one of those riots in the Bogside in 1981 that *Daily Mirror* photographer Cyril Cain was injured. Cyril and I and a couple of other photographers were near William Street. Cyril had had a couple of glasses of whiskey to boost him for what was to come. As the riot was going on, I saw Cyril going down and hitting the deck. I thought he'd just stumbled on the pavement so I started taking pictures of him, just for a laugh. The next thing, the riot stopped. This guy wearing a mask came across with a plastic baton round in his hand and shouted, 'You bastards, what are you like? He's hurt.'

When I saw the baton round I realized that Cyril really was injured. I used to be in the St John Ambulance Brigade so I knew a bit of first aid. Another photographer and I gave him a chairlift to the army lines, across waste ground. We went from taking pictures of a riot to being filmed ourselves carrying a wounded photographer.

It turned out that Cyril had been hit on the shin and had a really bad compound fracture. The cop who was taking his details down before the ambulance came asked him his age. 'Thirty-eight,' replied Cyril. I was laughing my head off but said to Cyril, 'Come on, this is serious.' 'All right ... forty-eight,' he conceded.

Alan Lewis

Shooting the Darkness

Alan Lewis

Gerry Fitt was a nationalist politician and one of the founder members of the SDLP. He was an outspoken critic of republican violence, which made him a target for IRA supporters. In July 1983, while he and his family were in Westminster, their family home on the Antrim Road in North Belfast was seriously damaged in an arson attack by republicans from the New Lodge area. He flew in the next morning to see the house for himself, and we went to take pictures. He brought us in – he was always very media savvy – and said, 'Come on upstairs and look at this.'

He took us into his bedroom. There was just a shaft of light coming through the window. I could see the picture but to get it with the equipment we had in those days was quite a challenge. We had only a 400 ASA film and the room was basically pitch black. I jammed the camera against the door frame and shot the picture for about two seconds. I knew there probably wasn't enough light to get the detail into the shadows. I went back to the darkroom and, using experience and a bit of guesswork, it ended up that the negative was just perfect. It summed up exactly what I had seen.

Gerry stood there motionless for more than the two seconds that the frame took. He was staring at his wedding album, which was burnt to a cinder on the floor, and he was just reflecting on that – it was almost like a Hitchcock moment. He later told me that he believed that the picture got him a peerage because the British government saw that moderate nationalism didn't have a voice in the area – after Gerry Adams had taken Fitt's West Belfast seat – and a way of giving that voice to them was to put Gerry Fitt in the House of Lords.

Shooting the Darkness

Alan Lewis

By the early 1980s, Martin Galvin – the publicity director of NORAID, a organisation that raised money for the IRA in the USA – had been banned from entering Northern Ireland by the British government. Sinn Féin then announced that they were going to bring him in on 12 August 1984; that he would attend a public meeting outside the Sinn Féin headquarters, Connolly House, on the Andersonstown Road in West Belfast.

I decided I would get a photographer to stand right in front of the platform to make sure that we would get a picture of Galvin if he was produced.

There were hundreds of people there, including women, and children in prams, and a heavy police presence. It was obvious that the RUC were going to try to lift Galvin if he appeared.

At the side of Connolly House there was quite a high wall. About a dozen of us managed to struggle up it, and being up there gave us a commanding view of the whole area. I wouldn't have been able to get a straight-on picture of Galvin, which was why it was important for my guy to be concentrating purely on the microphone, whatever else happened.

Galvin duly appeared, the police moved forward and all hell broke loose. There was shouting and screaming, police trying to get their way through the protestors who sat on the ground to form a human barrier. The police started to fire a few baton rounds. When rounds like that have been fired, the image that you want to get is of smoke coming off the baton gun. I was panning along, as were all the other photographers, and I saw one policeman who had been firing rounds, so I concentrated on him.

I heard the bang and hit the shutter straight away and I knew I'd got a puff of smoke, which was what I was looking for. Something quite dramatic. What I didn't know was that a man had run into the bottom right-hand corner of the frame and had been hit in the chest by the baton round. And then somebody shouted up, 'He's been hit,' and I saw a commotion and got down off the wall.

When I got back to the darkroom, I couldn't believe what I saw. I got a print up and I knew it was a cracking picture. I sent part of the picture up to Sinn Féin headquarters to have the man who'd been killed identified, and the word came back that his name was Sean Downes.

The picture went all around the world the next day and it led to me being called as a witness – the policeman was charged with murder and then manslaughter. The picture also caused the television companies who'd had guys up on the wall at the same time as me to go back and identify the point in their footage at which the incident happened. One of the companies had footage that showed Downes running in with a stick and the policeman firing between his two colleagues, and that ended up clearing the policeman in court.

That was a big day and the picture is one of the so-called iconic images from back then.

Shooting the Darkness

Louie Johnston (7) in tears as he follows his dad's coffin from the family church in Lisburn, County Antrim. Constable David Johnston (30) was one of two RUC community officers shot dead by the Provisional IRA in Lurgan, County Armagh, on 16 June 1997, just a month before the IRA announced a renewal of its 1994 ceasefire.

Alan Lewis

'The older I'm getting, the more I'm starting to realise that we were doing something special'
Hugh Russell

My route into photography isn't similar to anyone else's. I was picked to box for Ireland in the Olympics in 1980: I went to Moscow and won a flyweight bronze medal. I arrived in the Olympic village on the first day and was there until the second-last day, and I had hardly any chance to spend the roubles I had brought with me – and I had to spend them there because you couldn't bring them back with you. I bought a camera – a Zenit with a rifle grip on it. Probably not the best purchase I've ever made in my life but it got me started in photography.

When I came home to Belfast, I had a profile. The last boxing medallist in Ireland before me was Jim McCourt, who'd won at the Olympic Games in Tokyo sixteen years previously. The profile I had did me as much good as anything else because it got me talking to people, and people talking to me. At least 50 per cent of our job – maybe more than that – is talking to people. The easiest thing to do is taking the picture. The challenge is making the person feel comfortable so that they will do what you want them to do, or help get you to where you need to be.

I became a photographer because when I was boxing, the journalists and the photographers used to come to the house. Brendan Murphy, the staff photographer at the *Irish News*, was there one day and saw the Zenit sitting on the sofa. He asked if I was interested in photography. I said that I was, and after that he took me under his wing and trained me for a year. I've been at the paper ever since. Brendan also took a photo of me leaning out of the ring to kiss my mum after a fight, which won sports picture of the year for him, and which I think is probably the best sports picture I've ever seen. It's personal to me and I have it in the house. Brendan and I became chums for life.

Shooting the Darkness

Hugh Russell

For me, the men or the women who were shot on their own, waiting to go to work, or washing the car, are some of the murders that stick most in my memory. Their houses seemed more sorrowful to me than any of the others.

There was one shooting that happened on a Sunday afternoon. We heard about it, so we went up to just off the Falls Road. Sectarian killing. It was a Catholic washing his car who had been shot dead by loyalists because he was a Catholic, nothing else.

Often when we went to scenes like this, the street would have been blocked off. This time there were two Saracen tanks across the road, trying to block the view to the car and to where the gentleman was lying with a blanket over him. Back then forensics wouldn't have been there early. Bodies would have been left out for some time. There were no such things as forensic tents. If you were lucky, someone put a blanket over you.

I went back up and the police were outside, and I said to them that I wanted to take a picture. And just then a lady stepped out of the house and started to pray over the body. And it was always a picture to me. Never a picture that won anything major, but always a picture that I had in my mind. I think it was because of the innocence of the person that was killed.

Shooting the Darkness

Hugh Russell

People often look at press photographers and say, 'You have all the good gear and the best cameras.' I mean we have nice cameras the way that taxi drivers have nice cars. But I took this picture with a wee compact camera that I had in my bag. I was down getting something out when John Harrison, Lord have mercy on him, rapped the door. A child opened it. She'd a wee nightdress on and there was this big row of bullets right down the door. I couldn't get up quickly enough to get the main camera out, so I got the compact camera and just took one picture. The beauty of the picture to me is that it shows that you don't need to have all the bells and whistles. I still think that it's one of the strongest pictures I have ever taken. No one had been hurt or killed that time. It was a strong picture because of the elements that were in it.

Shooting the Darkness

The signing of the Anglo-Irish Agreement at Hillsborough Castle on 15 November 1985. The agreement, signed by Prime Minister Margaret Thatcher and Taoiseach Garret FitzGerald, gave the government of Ireland a consultative role in Northern Ireland affairs. We were all called down for the signing – security was incredibly tight, and the room was packed. I remember getting into the room and getting the picture, but not getting anywhere near where I wanted to be. All the big agencies knew this was a world-changing time, so all their photographers were up at the front.

When I took this picture I was still a young lad, and I had no idea that I was taking a picture that people would still be talking about today – it was a moment of history. The sense of history in the picture has got stronger as the picture has got older.

Hugh Russell

I always remember the first award that I won for press work. It meant a lot because I knew back then that I had scored something among my peers. I was up there with them and doing the same thing. I wouldn't have been shy of asking people the best way to do things. I always got different people advising me in different ways. Brendan Murphy used to always say that he didn't want cabbage patches, as he called them, in photographs. If there were two people, he'd want their heads very, very close together, so there'd be no spaces. I always remember being told by Cyril, one of the guys that worked for the *Mirror*, to put on a longer lens than you think you need, to help you 'to keep them in close'. The boys – the other photographers – were very kind to me and they looked after me.

On 24 February 1988, two UDR soldiers were killed as they arrived to close the security gates on Royal Avenue in Belfast city centre. We went down and I always remember Fred Hoare, another photographer, advising me to stay back a bit and keep the gates in, because the gates were as much a part of the story as the jeep. I ended up taking a picture of the jeep framed within one of the circles of the gate. We called the photograph 'Ring of Death'.

All the stuff that we used to try to keep out is now the strong part of the picture. On the right-hand side of the picture is where CastleCourt would be now. Royal Avenue hasn't changed that much, but the gates that everyone took for granted then add the interest now.

Hugh Russell

Shooting the Darkness

Hugh Russell

The picture that I will probably be remembered for most is of Gerry Conlon coming out of the Old Bailey on 19 October 1989. Back then the story about the miscarriages of justice was only starting to come out. The Guildford Four (three men and a woman who were wrongfully convicted in 1975 of the Guildford pub bombings, in which five people were killed) were the first to be released.

They sent us over to London to cover the release, which was a huge story. And I suppose it was a massive gamble back then because they didn't often send journalists or photographers away. I remember going to the Old Bailey and everything was sealed off. We were a million miles away. Couldn't see nothing. I was standing there and a guy said to me, 'You're the wee boxer, aren't you?' I started to laugh. He said to me, 'What are you doing?' and I replied, 'I'm trying to get closer.' He told me to come with him.

It turned out he was a builder and he took me on to the building site, which was opposite the Old Bailey. He got me a paintbrush and he said to me, 'If anybody comes past, just start painting the wall.' I splashed paint on this wall for about five hours – to this day my painting skills are still no good.

Then we heard they were coming out, so I went down to the front and was near enough right outside the front door. There was a big policeman standing there. I remember him looking at me but, being truthful, I think that because the equipment I had with me was so minimal, he thought I was just an ordinary Joe.

When Gerry Conlon came out the door, he did the big punch and I took the picture. I knew I had pressed the button at the right moment and then, when I processed the film in a darkroom in London, I knew I had a really good picture. Mine were the only pictures of him coming out so the best thing about it is that, like most good pictures, there's nothing to compare it to.

Shooting the Darkness

Hugh Russell

I took this photograph at the final RUC passing out parade on 18 August 2000, before the force's name changed to the PSNI. We probably wouldn't have been able to publish the officers' faces without pixellating them – which was an option by 2000 when cameras were digital – so I took the picture of them marching away, signifying the end of the RUC.

Shooting the Darkness

Hugh Russell

Joe O'Connor was a dissident republican who was killed in West Belfast on 13 October 2000. At his funeral there was one of the last republican shows of strength. No one had told us for sure that it was going to take place, and I just happened to be in the right spot.

Shooting the Darkness

Holy Cross, a Catholic primary school for girls, was in the middle of a Protestant area in Ardoyne, North Belfast. In June 2001, parents and children entering the school were attacked by loyalists. The picketing and attacks continued until the school holidays and resumed when the new school year began on 3 September.

For weeks, hundreds of protesters tried to stop the schoolchildren and their parents from walking to school through their area.

I got to know people personally, including Father Aidan Troy, who was chairman of the Holy Cross board of governors.

Hugh Russell

At the start of September, I am often in schools, taking the photographs of the P1 kids on their first day at school. In September 2001, I was at a school as usual, taking the usual kinds of pictures, when I got a call telling me to go immediately to Ardoyne. It was day and night between the kids I had been photographing earlier that day and the girls at Holy Cross. For weeks there was a really scary atmosphere – the loyalists were throwing everything you can think of at the girls and their parents, including blast bombs. I remember the girls with wee red jerseys and wee red faces. It was heartbreaking.

'That's the nature of working in a job that you're passionate about – you're prepared to take a risk'
Martin Nangle

Those summers of 1969 and 1970 were the end of my youth and the start of manhood. Popular music flourished. Civil rights movements were getting attention and, on 20 July 1969, I sat up all night at my friend's home in Lurgan, County Armagh, to watch *Apollo 11* land on the Moon. Closer to home, during the following month, the conflict known as the Troubles began.

Something else happened that last weekend in August 1969 that took me beyond the grimness of political unrest and violence. I heard a news piece on BBC radio in which the presenter played the first verse of Bob Dylan's 'It's All Over Now, Baby Blue' and then referred to the end of the second Isle of Wight pop festival. With the Woodstock Festival just a fortnight before and now hearing about the Isle of Wight I started to feel left out. This flower power thing appealed to me, if only because I wanted to belong to a bigger brotherhood of like-minded individuals. It was a welcome alternative to the daily news of local mayhem and the international news of potential nuclear obliteration.

I became passionate about the idea of going to the next Isle of Wight festival, and by the end of June 1970 I had enough money to get to London and then on to the festival. When it was over, I took to the road to participate in the counter-cultural revolution. But after some months on the road, the appeal of that lifestyle wore off.

It was my Aunt Margaret in Birmingham who steered me towards photography and the career that would eventually define my working life. My next steps took me to the Ulster College of Art & Design to study art and photography in Belfast, a city in the process of ripping itself apart.

Shooting the Darkness

When I got to college, the photography grew in a natural way and my desire to document life in a visual way came together with my favourite subjects of history and geography – everything married well together. Belfast wasn't my home, so when I saw the city for the first time I was shocked. I'd had no idea of the extent of the decaying grandeur that was evident everywhere. This quite proud Victorian city was basically rotting around us and falling apart, both socially and politically. I thought to myself that, as part of the art college project, I would try to capture that.

Martin Nangle

Belfast's old districts of the Half Bap and Sailortown were close to the art college. Between 1971 and 1975 their streets and wastelands provided fertile material for my first documentary project.

Shooting the Darkness

Martin Nangle

The Half Bap and Sailortown, 1973.

Shooting the Darkness

When I left college in 1975, I chose the path of journalism and documentary photography. To get a job as a press photographer I needed a portfolio so I took a job as a medical photographer at the Royal Victoria Hospital. The hospital was in the heart of West Belfast, home to constant paramilitary and British Army activity, and had cameras that I would appropriate nightly from the safe. A few hours of daylight each evening, at the time when most people were heading home, allowed me undisturbed periods during which I could walk the city's decaying back streets in search of images. Taking the pictures was the easy part – trekking around the papers asking for any work that was going was entirely depressing.

The photographic department's office at the hospital overlooked this section of the Falls Road, so I took this photograph from there during a riot. There was a view in the department that sticking your camera out of the window to take a picture was chancey, because you could have been suspected of working for the security forces or trying to identify the people involved in the disturbance, but I was always prepared to do it to get the picture. That's the nature of working in a job that you're passionate about – you're prepared to take a risk.

Martin Nangle

It took eighteen months but by January 1977 I had a job at Pacemaker Press, my 'home' for the next twelve years. It was a shaky start – I had little experience, basic equipment and no planned route for success. It was jump in: sink or swim.

Before long, the agency achieved main-player status, working with mainstream media, the police and security forces, and the various political parties' publicity departments. We also engaged with a subterranean world that was beyond the comprehension of most members of society. As a private agency we offered our services to everyone and anyone.

This led to us mixing with some of the most devious and violent murderers in the history of the Northern Irish Troubles.

Martin Nangle

A Provisional IRA member at a show of strength at
Casement Park, West Belfast.

Shooting the Darkness

A soldier on the Falls Road using his gun's sights to monitor what's happening in a riot during the Hunger Strikes in 1981. A member of the RUC crouches beside him.

Martin Nangle

I took this photograph of a member of Cumann na mBan, an Irish women's republican paramilitary organisation, in the late 1970s on the Falls Road. The woman was part of an active service unit that appeared at a rally and caused quite a sensation.

Shooting the Darkness

Martin Nangle

Divis Flats with the spires of St Peter's Cathedral in the background in 1983. For me, this picture sums up the reasons why places like these were an obvious recruiting ground for the IRA.

The area was also plagued by joyriders, who would steal cars and burn them out on waste ground. I was there doing a story on a joyrider who was defying IRA warnings to stop and was subsequently shot. The photograph makes clear the hopelessness of life at that time in that part of the city.

Shooting the Darkness

Martin Nangle

In March 1988, there was a series of three related events: in Gibraltar, the SAS killed three members of an IRA bombing team; Michael Stone attacked the funeral of the IRA members at Milltown Cemetery, killing three and injuring more than sixty; and two off-duty corporals who drove into the funeral cortège of one of Michael Stone's victims were dragged from their car, stripped and killed.

I was actually off the day of Michael Stone's attack at Milltown – one of my few days off – but I was working the day of the funeral of the IRA member, Caoimhín Mac Brádaigh. And, as it turned out, it became a major incident, when the off-duty soldiers drove into the cortège. It was definitely one of those situations when I shut out the reality around me because I was looking through the viewfinder of my camera. The camera just kept on working. Immediately afterwards, some kind of instinct kicked in: I knew that if I wanted to get this story out, I would have to hide the film with the images. I put in and wound on a new film, so that when I was asked to hand it in, I could rip it out and it would look like it was being destroyed. I was able to slip away and hide the original film in the car.

You have to remember that I was already about seventeen years into my career by then and that I had been covering the Troubles for thirteen of those. I knew that what was happening would be over as quickly as it had started and that the reaction would come a little bit later. I also knew this was serious, that I needed to get out of there and secure the film. And it worked in so far as the story got out and the images got out.

Shooting the Darkness

Martin Nangle

I don't think these images are good at all. They're good from the point of view that they record the event. They ended up being used as evidence in a criminal trial. But, from a photographic point of view, they're not that strong.

However they were the only pictures, and they showed the savagery and brutality of that day. They brought an awful lot of attention from Dublin, London and Washington, and maybe made some people think that they needed to speed up the peace process.

'There's intuition and instinct, but on top of that there's luck'
Crispin Rodwell

I was born into a media family – my mum did some broadcasting for the BBC and my father was a journalist. We moved to Northern Ireland from the south of England in August 1969, when I was seven. I had a nice, comfortable, East Belfast upbringing, largely untouched by the Troubles that were starting to gather pace through my early school years.

I left school at nineteen and with no college education went to London to work as a trainee darkroom printer in a press agency. The costs of living in London far outstripped my meagre salary so I only gave that three months. I did another few weeks on a local newspaper in Oxford before I came home to start freelancing like my father.

Quite by chance I began working in the first few days of March 1981, in the same week that Bobby Sands started refusing food. My very first set of pictures was used in *The Times* a few days later. My association with the paper continued for the next twenty years.

Very early in the morning on 1 June, three months to the day since my start, I remember Mum coming out of Dad's office in our Ballyhackamore home very distressed. A very dear family friend, Colin Dunlop, had been shot dead by the IRA while guarding a prisoner in the Royal Victoria Hospital. He had been in the RUC for only four months and was the father of four young children. He was thirty and one of my closest friends. By that stage four hunger strikers had died in the Maze and I was very busy covering the protests, riots and funerals that were happening daily.

Fourteen weeks later, on 7 September, another very close friend was murdered. Mark Evans (20) was also in the RUC. We had grown up and gone to school together. He was also a neighbour. Mark was blown up in an IRA landmine blast, along with a colleague, on his very first day stationed in Pomeroy in County Tyrone. Like Colin, Mark had only been in the police for a few months.

I covered in the region of 70 funerals of the 111 Troubles-related deaths in 1981 but I would never have expected to have been mourning my closest friends at two of them.

Shooting the Darkness

The first pictures I remember taking in my freelance career were of some communications that had come out of the Maze Prison in March 1981. They were written on sheets of toilet paper in microscopically small handwriting, folded into little pellets, wrapped in cling film and brought out in the mouth of a prisoner's relative. They ended up being sent to Dad, who wondered how the letters were coming out this way, so he did some research. He discovered that they had been smuggled out of the prison by the mother of an IRA inmate. She was happy to pose with some of the letters, and *The Times* ran the story and my images. The prisoner who wrote the letter was killed six years later when the bomb he was throwing at an RUC station exploded prematurely.

Crispin Rodwell

Dear Bob, 6-3-81 H Blocks

First of all I will have to apologise to you for having to use this toilet paper. Forget about the quality of the paper but I do write to you in all sincerity and appeal to you for your help to save the lives of comrades on hunger strike to the death for political status here in the H Blocks and Armagh Jail. At present there is only one person on hunger strike Bobby Sands from Belfast but he will be joined later by more of our comrades. I hope you will read this and pass it on to your fellow journalists as I have went to the trouble to write this out and smuggle it out of the H Blocks. To asked for your help to save lives of Irish POWs. Well Bob I am a republican prisoner I was caught in April 76 sentenced by a Diplock juryless court to 15 yrs for possession of a bomb in Belfast I came to the H Blocks in October 76 and as I wasn't a criminal I refused to wear the criminal uniform or to do criminal work. A peaceful protest from the start on our behalf. So you see this is not a protest for better prison facilities. We are political prisoners, being tortured at the hands of the British. If you look back over our history at the hands of the British it makes very sorrowful reading. Which I will not go into now as space is precious.

Since the end of the last hunger strike in which the 7 men came close to dying especially Sean McKenna from Newry, the feeling was an agreement had been reached between the British government and the prisoners. Then late December 80 and early January SINN tried the step by step approach to phased out the protest. In order not to cause the British too much embarrassment in to accepting that the republican prisoner had got what we wanted (political status) just like our comrades in the compounds of Long Kesh, which our friend Enoch Powell MP is always pointing out why the still are being treated different from the common criminal. The phasing out of special category status in March the 1st 1976 didn't mean an end to the special interrogation centres (it was after 1st March 76 that the Amnesty International report dealt with) Diplock juryless courts continued to sentence on the statements obtain by the RUC Northern special interrogation methods. So this is how the majority of the youth ended up here in the H Blocks and Armagh Jail. So now you know when the British government talk about arian side they are working on. You will know it is more they could have avoided this hunger strike but they petty and vindictive in there handling of the situation. The British have ignored all attempts by us to end this respectively for both sides. But all we got was more inhumanity

So now at this tragic time I appeal to you and anyone interested in our struggle. To support us to apply pressure to the British to save these noble Irish lives because the British imperialist government will take joy in letting them die. Bob if you are looking further information on the developments in here. You can write to my mother my home address is 3 Colinward Street, Springfield Road Belfast 12. She will only be to glad to help you. Please used your influence to help Bobby and his comrades who will be joining him on hunger strike to the death. No matter what you do no matter how small every thing helps you will hardley get this published in your own paper with your editor there but I hope you can help Yours hopefully Finbarr McKenna

Shooting the Darkness

Crispin Rodwell

After two years of working from home, I rented an office in High Street in Belfast. One August evening in 1988 I left the office for home and less than a minute into my journey, at traffic lights on Middlepath Street, the Ford Capri directly in front of me exploded in a ball of flames. Instantly, it was an inferno. There was no question of anyone being able to survive the blast and the fire. Bits of debris rained down on the roof of my car – among them were the contents of the driver's golf bag. I pulled over at the side of the road and instinctively went into autopilot, shooting pictures. Another driver jumped out of his car with a fire extinguisher but couldn't get close enough and could do nothing to help. Within a minute or two, police Land Rovers from Musgrave Street came screaming across the Queen's Bridge, sirens blaring, swerving all over the road. One of the RUC men saw me taking pictures and came over and screamed in my face, 'Get back! Get back!'

I went straight back to the office and started processing and transmitting the pictures. The phone was going every couple of minutes with calls from reporters at newsdesks in Belfast, London and Dublin, saying, 'We hear you're a witness – so would you like to tell us what you saw?' and I was just madly trying to get the images out as quickly as I could.

The victim was forty-five-year-old Lieutenant Alan Shields, a Royal Navy recruitment officer and a father of one. He too had just finished work and was on his way home to Bangor.

Pictures of the burning car ran in many papers and on TV the next day. It was an experience that I still remember very vividly thirty years later – the intensity of it. I had never witnessed a murder before, particularly from only a few feet away.

Shooting the Darkness

Funerals were a huge part of our work. I remember doing double funerals, triple funerals, and after an atrocity we would have funerals for several days on the trot – we'd see the same faces at them and the same politicians would turn up to follow the coffins. Were we affected? Absolutely we were affected. You can't come away from a funeral with thirty school kids weeping as the coffin of their classmate goes by and not be affected. There were heartbreaking scenes: people collapsing as the coffin passed; children forming a guard of honour for one of their friends and having to be supported and taken out of the line by their teachers because it was too much for them.

We were always sensitive; we had emotions and empathy and young children as well, and of course we felt the impact of being so close and reflecting and recording the upset as best we could without being overly intrusive. At the same time, we knew that what we were doing was very, very important. It was crucial. The world was seeing Northern Ireland through our eyes – we knew we had to get the story out.

Crispin Rodwell

These pictures show the joint funeral of fourteen-year-old Emma Donnelly and her grandfather Bernard Lavery (67) who were killed driving past an IRA bomb that detonated at Benburb RUC Station on 23 November 1988.

Shooting the Darkness

Every now and again a new degree of nastiness would enter the lexicon of the Troubles. On 24 October 1990, the IRA launched three 'human bomb' attacks against army checkpoints. Three Catholic men, who the IRA targeted because they worked for the security forces, were kidnapped while their families were held hostage. The men were then chained into the drivers' seats of vehicles packed with explosives and ordered to drive to security installations.

One of the bombs, that was driven to an army camp in Omagh, failed to detonate. Another killed a soldier at Cloghoge, near Newry. At Coshquin near Derry, Patsy Gillespie, the man who was forced to drive the bomb, and five soldiers were all killed. I shot the aftermath of that explosion initially from an aeroplane, as I often did after landmine blasts. Only from the air was it possible to see clearly how devastating and widespread this blast had been. It was one of the border posts, or lookout posts, with fortified accommodation for the soldiers and as it happened in the middle of the night, most soldiers were sleeping and escaped. Virtually all of the checkpoint, a number of armoured vehicles and the security fencing around it had been destroyed by the bomb.

I can't remember at what stage we learned that the bomb had been delivered by somebody chained into the vehicle and forced to drive to their death – but certainly it introduced a new nastiness into the Troubles. The practice backfired on the IRA in terms of public opinion and it was never used again.

Crispin Rodwell

Shooting the Darkness

On 23 October 1993, I was doing a day's work for the *Sunday News*, the now defunct sister paper of the *News Letter*. It was a Saturday and I was in the office, probably waiting for a job to come in, when we heard an explosion. The news editor found out very quickly that it was on the Shankill Road.

I jumped straight in the car and I was up there probably seven or eight minutes after the bomb had gone off. Even at that stage there was already a police cordon around the blast site. Frizell's fish shop had been demolished. There was pandemonium, with people believed to be trapped under the rubble. Lots of ambulances and emergency services vehicles were arriving as I pulled up, and I could hear sirens coming from all directions and from far away. There was still a lot of dust in the air, brickwork was falling into the space where the shop had been, and there was a lot of screaming, shouting and crying.

I could see one of my photographer colleagues inside the police cordon, shooting pictures ... but a policeman pushed me saying, 'Get away'. It was clear that there were many casualties – I could see the ambulance crews deploying stretchers and tending to bloodied and dust-covered people.

I managed, in the melee, to get past the policeman and inside the cordon, but I shot very few frames – probably only half a dozen – before more police arrived and pushed everyone back. Lots of walking wounded were being led away but then a body on a stretcher was carried out past me and I shot that frame as we were being pushed back out of the way. Although I had taken very few pictures, I knew I had a key image: I had the rubble with dust still in the air and a mix of policemen, firemen and locals carrying out the body of one of the victims.

The IRA had targeted what they thought was a UDA meeting happening in a room above the fish shop. One of the bombers was killed when his bomb exploded prematurely, as were nine innocent people, including two children. Fifty-seven people were injured.

Crispin Rodwell

The funeral of three of the victims of the Shankill bomb: Michael Morrison (27), his partner, Evelyn Baird (27), and their daughter Michelle (7). The cortège stopped at the site of the attack.

105

Shooting the Darkness

Crispin Rodwell

On the last day of August 1994, I was working for the Reuters wire service. We were aware that the IRA was about to announce a ceasefire which would be a very big national and international story: the culmination of the early stages of what would become the peace process. I got an early morning call from the picture editor asking me for a picture to illustrate the anticipated IRA announcement.

How do you illustrate the intangible? How do you photograph an announcement that hasn't yet been made, or something that hasn't yet happened? More often than not it is going to be images of troops on the streets, or an apposite slogan painted on a wall, or a poster – photographing 'peace' before it actually materialises poses all sorts of problems.

That morning I was heading to Belfast Zoo to photograph a baby gorilla that had been born overnight. As a local photographer there were normal everyday photographs to be done – it wasn't just bombs and bullets, murder and mayhem.

On my way back down the Antrim Road after photographing the gorilla and still conscious that I had to shoot what Reuters had requested, I was on the lookout for checkpoints or army Land Rovers or whatever. I saw some kids playing in a side street in front of a slogan on a gable wall that said, 'Time for peace, time to go'. I stopped to see if I could make something of it, so I shot twenty-three frames of the children playing on their bikes with the slogan as a backdrop. Then a boy came out of the house and started throwing a ball against the wall, so I photographed him. This was all pre-digital, so I couldn't look at the back of the camera and say, 'Oh, that'll work.' I simply knew that I had pictures of children playing street games.

I got back to my office, processed the films and sent a couple of pictures to Reuters in London. The same picture editor called and said, 'Well, that'll do for this evening's papers, Crispin, but can you go out and see if you can get something stronger for tomorrow's papers?'

So I went out again that afternoon looking for the pictures that I'd assumed I'd get in the morning: of soldiers on the streets, policemen with guns, daily life going on in some of the more troubled areas. That evening, as I always did, I turned on BBC's *Newsnight* to see the front pages of the next day's papers. One after another, after another, had used the photograph I'd shot that morning.

The picture editor rang again the next morning at 7.30, as he always did, and said, 'By God, I misjudged that. The picture I thought would do until lunchtime – you're all over the world with it. You have publications in the States, in Australia, in the South China Morning Post and all over Europe.' Reuters used the image on their Christmas card that year.

It has been used again and again and again, in books, magazines and advertisements. And I still get requests for it, a quarter of a century later. It's really nice to have shot one of the pictures that people call 'iconic', that they recognise, and that has been seen all over the world.

Shooting the Darkness

One of my favourite photographs, which ended up winning the news picture of the year award in 1995, was taken during a republican parade which was making its way down the Falls Road to Belfast City Hall. The decision to permit the march to take place outraged local loyalists.

One of the republican marchers broke away from the parade and jumped up on a wall and started goading a bunch of loyalists from the nearby Lower Shankill, who were watching from some distance away. The photograph shows a policeman trying to pull him down so that he doesn't antagonise the crowd. There are a dozen loyalists all reaching for him, screaming at him, hatred and venom in their eyes.

That's one picture that I am still very proud of and really like, even though on a national scale it's nothing – two factions of Northern Irish guys having a go at each other. It happened every day.

Luck certainly comes into play sometimes: there's intuition and instinct, experience and news-sense, but on top of that there's luck. I was in the right place, on the right side of the wall, and facing the right direction when this all happened in front of me.

A successful picture has to both pose and answer questions. I want the viewer to look a couple of times, to think, what's going on there? To look at the upset in the picture and to wonder what caused it. I also want to trigger emotions, for the viewer to be absorbed by the picture – to wonder what it was like, or to feel as though they were there. That's at the heart of it really – I want to create complete engagement between the viewer and the image.

Crispin Rodwell

Shooting the Darkness

The conflict between the Orange Order and the residents of the predominantly Catholic Garvaghy Road in Portadown in the mid- to late 1990s created a very tense time.

At one stage, it was reported that there were around 100,000 Orangemen and their supporters rallied in the fields beside Drumcree Church and the surrounding area, and at demonstrations all over Northern Ireland.

The field between the church and the Garvaghy Road started to look like a First World War battlefield, like no man's land. Every day, every evening, the crowds would swell in the fields and this went on for days and days. The army dug ditches and trenches, and put up huge Maginot-Line-type barbed wire entanglements to stop the protestors over-running their positions and getting on to the Garvaghy Road. We were all accustomed to the sight of barbed wire, but to see so many rolls of razor wire and several lines of it was extraordinary.

The press were barely tolerated and were *personae non gratae* to the Orange Order but we still had to go into the fields to photograph them and properly illustrate the story, which was of huge international interest.

Crispin Rodwell

During daylight, the Orangemen tended to be happy enough to have us around – they were doing fun things like eating ice creams and courting on the grass in the sun – but as darkness fell, the atmosphere became menacing, tense and uncertain. If the crowd turned on us, there was no protection.

Some days into the stand-off, when it looked as though this huge weight of people was going to puncture the security force lines, the RUC told us that they would be unable to protect us if the line broke. This was very sobering – it was the first time I felt that there was no backstop, no protection if things went horribly wrong. We could see people in the crowd who we knew to be paramilitaries on both sides, on the Garvaghy Road and in the field at Drumcree.

The security forces had set up these huge arc lights, pointing straight into the fields full of Orange Order supporters. I shot many hundreds or thousands of photographs each year when I was in the fields with them but one was particularly pleasing: a youth waving a Union flag with Orangemen around him, silhouetted against the barbed wire.

The whole Drumcree protest was like a pressure cooker, and we'd never seen the like of it before.

Shooting the Darkness

Crispin Rodwell

On 10 September 2005, an Orange Order parade that was due to march along the nationalist Lower Springfield Road in Belfast was rerouted to try to prevent inter-community disorder. During the rioting that was triggered by the rerouting, policemen were injured, blast bombs and petrol bombs were thrown, and live gunfire was directed at the security forces. The soldier walking towards me was warning me about unexploded bomb blasts and the live gunfire.

The image was used as a double-page centre spread in the *Guardian*'s first ever Berliner-sized paper two days later. I was thrilled to have the first photograph in that slot, which was called 'Eyewitness' and which became very sought after as a showcase by photographers from around the world.

'We take pictures; we don't take sides'
Paul Faith

I got my break early on, when I was about sixteen – I got a job as a darkroom technician at the local newspaper, the *Ballymena Guardian*. I progressed and, before too long, was taking local pictures. There was news in Ballymena but not at the time that I was there. There were soldiers on the streets but generally my daily work would be town hall receptions, dinners, parades in the town, the unfurling of Orange Order banners, local football matches and cheque presentations. I was just bursting to get out and do news. I felt as if it was my calling. My mum was really worried.

A colleague of mine left the *Ballymena Guardian* and joined Pacemaker, the leading photographic agency in Belfast. He was doing really well and they were looking for someone else to cover the Troubles. He rang me one day and asked, 'Are you doing anything?' We always had umpteen jobs on a Saturday and this day I had about fifteen, but I went, 'I'm doing nothing.' He asked me to go and photograph a runner from Dublin who was competing in a marathon or something.

They really liked the pictures and asked me to come up for a day or two to see how I got on at the coalface. One of those first days I was out at a republican internment parade and I had my eyes opened. I was really, really scared. Because I could see the hatred. The soldiers were scared. The republicans were vicious to them. And it was just a completely different world. I shook from one end of the road for the whole three miles to the other end.

I felt bad that day when I got back to the office. I hadn't great pictures; I'd missed a terrible lot. But it was a big learning curve – I knew then what I wanted to do and I just had to get settled into it.

Shooting the Darkness

The Ulster Resistance was a loyalist movement founded in November 1986 in protest at the Anglo-Irish Agreement.

That November, I was back in Ballymena. I was tasked to follow Paisley – so I had to clear that with him and the police bodyguards who were driving him around. Paisley and I had a good relationship because I'd photographed him in Ballymena in the earlier days. He'd got to know me quite well.

There was to be an Ulster Resistance rally in the town that night and there were thousands of people. Getting down there through the crowds was a bit hairy because a lot of the loyalists and DUP supporters weren't media friendly, and it would just have taken one of them to turn on me. So I stuck pretty close to Ian Paisley and Peter Robinson. There was talk that they were going to appear on stage together, wearing the red Ulster Resistance berets, which was something that hadn't happened before.

We got into the town hall. There was a lot of pushing and shouting. There was just one TV crew and me. I got up towards the front and said to Ian on the stage, 'Are you going to be wearing your berets?' And he said, 'Oh aye.'

So I moved on round to the front of the stage and, sure enough, they came out and put on the berets and the crowd went wild. They were absolutely loving it.

Those were very strong, striking images, especially at that time, but I was thankful to get out and get home.

Paul Faith

117

Shooting the Darkness

Most of the time, we arrived somewhere after something had happened. A bomb goes off – it's over. We were normally going in to cover the aftermath. One particular day in March 1987, there was a number of bomb scares in Belfast and a bomb attack on the funeral of RUC officer Peter Nesbitt at Roselawn. This was a new move by the republicans. They felt that IRA funerals were being 'attacked' by police when there were paramilitary trappings. So this was them basically saying, 'You won't let us bury our dead in peace; you'll not bury your own dead in peace.'

That day, I'd been to the scene of about half a dozen suspect devices and I was getting fed up. When I got down to Smithfield, I asked the cop there, 'Is this another hoax?' And he replied, 'Who knows? They're all over the place today.'

I was just looking up the street when I saw the building open up in front of me. I didn't hear the bang, I just saw the building. And then came the noise and the shockwave, and the soldiers and police running. The first frame was in the air, the second frame was on the ground, and the next couple of frames were on target. Manual focus in those days.

When I got back to the office, I said, 'I may have a bomb going off.' And the guys were like, 'Yeah, right.' The first print didn't look great but when I printed it again on harder paper, it turned out to be a cracker. It won me a few awards and travelled really well. The next year, I won press photographer of the year and that picture was part of the portfolio. I got engaged to my wife with the proceeds, which cleaned me out. The ring cost a fortune!

Paul Faith

Shooting the Darkness

Larry Marley was shot dead at his home in the Ardoyne district of North Belfast by the UVF on 2 April 1987. We went up to get the collect from the family and, as far as we were concerned, it was going to be just another funeral. It turned out, though, that Marley was an IRA guy.

On the day of the funeral, we went up, and the police were there in force. They were determined that there would not be any IRA show of strength. We were up by the door, waiting for the coffin to come out, when the family said, 'Guys, sit tight. This coffin isn't going anywhere until the police go.' And a next-door neighbour said, 'Why don't you just come in and you can shoot out of the window upstairs?'

So we were beside Larry Marley's house in an upstairs bedroom. Height's your friend when you're a photographer. It keeps you out of harm's way, plus you can see everything that's going on and shoot without being bothered. For two days we sat in the house, and we were given lunch and coffee and tea and home-made apple cake – it was great – while we were photographing all the chaos and fighting that was going on outside.

Paul Faith

Belfast was in flames. There were burnt-out vehicles right along the Falls Road, the planned route of the funeral. There was lots of rioting going on. Finally the cortège did move off and, sure enough, there was trouble. Every few hundred yards there was more fighting and baton charging. The police were determined that there wasn't going to be any sort of show at this funeral but it grabbed headlines around the world. It took three days to bury a man.

Two IRA guys, Brendan Burns and Brendan Moley, had been killed in Crossmaglen by their own bomb on 29 February 1988. I was tasked to cover the funerals, which took place on 5 March. I knew there was going to be a massive security operation. It was bandit country – the police and army didn't move in vehicles there; they couldn't for fear of landmines. Instead they had to move by helicopter.

By the time we got to Brendan Burns's home on the outskirts of Crossmaglen that morning, the police had made it clear to the family that they would move in if there were any paramilitary trappings.

The police and army were there in force with riot shields. It's a rural area and they'd smashed down all the walls and hedges on either side of the funeral's route so that they could walk through the fields, in tandem with the hearse, as it travelled from the house.

The coffin came out of the house. There was no noise from the mourners. The soldiers and police were clambering through all these ditches. There was a funny feeling about the whole thing. And then, all of a sudden, either a whistle or a horn sounded. It was a signal – the hearse took off and all the mourners ran. I didn't know what the hell was going on so I just followed the mourners.

'Where are we going?' I asked one guy.

'Where are you from?' he asked.

'The *New York Times*,' I replied.

He just threw me into the back of the car.

'What's going on?' I asked.

'They're not going to tell us how to bury our dead,' he told me and we sped off.

All the mourners headed off through the countryside. The police and army were left red faced because they had brought everyone in by Chinooks and Wessexes and had no other transport. They had to start ordering the helicopters back. They knew they were on a tight timeframe because if the IRA were going to do anything, it had to happen directly after the coffin came out of the chapel.

When we got into Crossmaglen there were about 1,500 people waiting for this coffin. It was stopped outside by the priest, who removed the tricolour and blessed the coffin before it went inside.

As the service was ending, Chinooks were landing beside the graveyard. It was like something out of Vietnam with the helicopters and the down draughts. I was told to go around the back so I had a fair idea that something was up. As the commotion grew around the church, six IRA guys arrived in full camouflage gear – woolly masks, berets, the whole lot. They lifted the coffin and started to walk with it. Martin McGuinness was at the front. No words were spoken. I was photographing away. I had maybe taken twenty frames before I was pulled back, turned around and the IRA men were gone, replaced by family members.

The security forces had lost this one. The Provos had played their ace and got what they wanted. This picture of Martin McGuinness beside the IRA guys travelled the world, and came back out again when he became deputy First Minister to show his close association with the IRA.

Paul Faith

Shooting the Darkness

It was August 1989, the twentieth anniversary of the outbreak of the Troubles and there was lots of talk in Belfast that the violence was just going to go off the scale any day. We'd all been out the night before I took this picture, having good fun until the early hours of the morning. The boss rang me and said, 'There's rioting in Ballymurphy.'

I said, 'Aye, that was last night.'

He said, 'No, this morning.'

I replied, 'But it's only half past seven.'

'It's definitely happening. There have been buses hijacked, and they've been–'

'Right, okay,' I cut him off.

I went up to Ballymurphy and, although I didn't see any vehicles on fire, there were people squaring up to the soldiers. The squaddies were on edge – one in particular was crouching and looking right down the street into Ballymurphy with his SA80 pointed. A woman came up and shouted right down the barrel of the gun. Although there was no physical contact it was a violent altercation – you could see the venom and hate between the republicans and the soldiers.

I shot a few pictures and went back to the office. The Reuters and Associated Press and other photographers were all arriving because they used Pacemaker as a sounding board for what was going on. Marty [Nangle] had seen the picture and told them that I had a good one in the darkroom. So they came and saw it and their faces sank because in those days the big agencies just needed one iconic picture and that day it was mine.

Paul Faith

Shooting the Darkness

On 16 November 1990 Margaret Thatcher flew in to Northern Ireland to visit an outpost on the border that had been attacked by the IRA. This was a no-go area and her visit was a nightmare security-wise.

Lots of media were pitching to get into the helicopters. Pacemaker was well in with the officials, and I said, 'Look, a local agency needs to be on this.' So I was on the first Puma, she was on the second Puma, and there were about half a dozen more Pumas, Lynxes and Wessexes. The security forces were worried that some IRA unit would have a rocket launcher or a missile and would take out Thatcher. She would have been their number one target.

When I got on to the helicopter, the pilot said, 'I hope no one has a queasy stomach because we're going to be riding the treetops.' And Jesus, he was right.

The door was open throughout the journey, the guy was there with his belt-fed machine gun. It was the best helicopter ride I ever had in my life. We took quick tight turns following the contours of the land – but it wasn't like a jolly: it was the real McCoy.

We landed ahead of Thatcher, and I remember her coming out with her handbag and her welly boots. She just looked like someone who'd been walking around in a field. She met the soldiers at the checkpoint that had been attacked and went into the bunker where the soldiers with heavy machine guns and blacked-out faces and sandbags were.

It's nice to have photographed her on a number of occasions. This time turned out to be less than a fortnight before she resigned.

On 16 February 1992, four IRA men were killed by the SAS near Coalisland in what became known as the Clonoe Ambush. I needed to get the collect of one of them, Kevin Barry O'Donnell, so I went to see a local Sinn Féin councillor to ask if he could help. He took me up to the house, which was completely surrounded by police. In those days I carried a Nikon camera, a motor drive lens, a flashgun, and so on, so I took everything off and apart and put the lens in one pocket, the flashguns in another, and tucked the camera beneath a double coat.

The police knew the local councillor but didn't know who I was. But we weren't stopped – we went on into the house. The family gave me the collect and I photographed it. And then they asked if I wanted to take the guard of honour picture. They opened the door and there was the open coffin with five IRA guys standing around it. The curtains were pulled because they couldn't have the police looking in the window.

I thought that there might be an issue because of the flash, especially when the family asked me to take pictures with them as well. I thought to myself, I need to be working quick here. These guys outside aren't stupid. They must see all these flashes going off behind the window.

Before I left the house I took the film out, rewound it back and stuck it down my sock. Then I put another film in and shot it forward. If there was going to be an argument outside, I would be ready.

In fact we left without being stopped. I got back to the office and was printing up the images when, by coincidence, someone from Sinn Féin called into the office to talk about an event that was coming up. He looked at the picture. 'When was that taken?' he asked. 'A couple of hours ago, down in Coalisland,' I replied. Then he asked if the picture had been used, so I explained that it was on the wire and away. He said, 'That guy's going to get recognised.' There was a heavy-set man in the picture and I could see that someone might pick him out.

A few days later I went to the funeral. The police warned the family that they would move in if there were any paramilitary trappings. So the republicans walking alongside the coffin were in white shirts, black ties and glasses. At the front of the funeral, there was this big, heavy-set guy walking along. And he just looked at me – I think he might even have lifted the glasses and winked at me before he dandered on. It was the same guy that was in the guard of honour picture. He was maybe scooped later on but he was still a free man at that point.

Paul Faith

Shooting the Darkness

On the evening of 18 June 1994, I was at home in Carryduff. I could hear sirens going past the door so I rang the police press office to ask what was happening. The person who answered told me that there had been a bad shooting at a pub in Loughinisland and that there were multiple casualties. It turned out that the UVF had burst into a very small bar, shooting six people dead and wounding five.

I headed down that night but there wasn't much to photograph. The next day we went for the collects. We knew that one of the victims had been a good age but the photographer working with me hadn't been able to find the family's house. I knew that it was an important photograph to get so I found the house and apologised for intruding but the family were lovely. They brought out a photograph and, as soon as I looked at it, I saw that the victim, Barney Green, looked just liked my grandad. He had a hat on and a pipe. It turned out that he was one of the oldest people killed in the Troubles.

We brought the picture back to the office and it was used on quite a few of the front pages the next day, along with the other collects we'd got, plus the scene at the bar. The bar was so small that it looked like an eight-by-eight shed and it was just covered in blood.

That picture of Barney Green played its part – these images all became part of the peace process. We didn't get where we are without the pictures and news stories appearing.

Paul Faith

I didn't go to Omagh on the day of the bomb, 15 August 1998, but I went down the next day. I used the long lens and trained it on the bridge looking up towards Omagh. Up the main street there was total carnage. I'd been there a few hours and there were only a few police and forensics guys walking around the scene.

I remember watching a policeman picking through things. I could see him lifting something up and crying. I couldn't work out why, and then I saw there were two kids' mangled buggies. The policeman was only there for a couple of minutes. It was over as quickly as it had started. But I just knew that particular image would travel.

The bomb in Omagh caused the deaths of twenty-nine people, many of them children.

Paul Faith

About the photographers

Stanley Matchett was the first photographer in Northern Ireland to be awarded an MBE for services to photojournalism. He holds an Honorary Fellowship of the British Institute of Professional Photography and a Fellowship from the Royal Photographic Society. For over fifty years, he has photographed presidents and prime ministers, politicians and personalities. He worked at the *Belfast Telegraph* and *Daily Mirror* before going freelance in 1990. He has been named Sports Photographer of the Year three times, and has contributed to many prestigious publications, including *Life*, *Paris Match* and *Der Spiegel* magazines.

Trevor Dickson worked as a wedding and portrait photographer before joining the weekly paper, *Cityweek*, in 1965. He moved to the *News Letter* in 1970. He won multiple awards, including the Ulster Sports Photographer of the Year three times; every section in the Northern Bank Press Photographer of the Year at least twice, and was the overall winner twice also. He won the Rothmans Press Awards Photographer of the Year award three times and was runner-up another year. Trevor's career was brought to an end following a car accident in 1992 – due to the seriousness of his injuries he was unable to return to work.

Alan Lewis joined the original Pacemaker Press staff after leaving Queen's University Belfast in 1971. He went on to work for the *Daily Mail* before forming the Photopress Belfast picture agency. He has won many photography awards, including the Northern Ireland Photographer of the Year (three times) and the All-Ireland PPAI Photographer of the Year. He was a founding member of the Northern Ireland Press Photographers Association (NIPPA), and has served both on the committee and as chair of that organisation.

Hugh Russell has been a photographer at the *Irish News* in Belfast since the early 1980s and has won multiple awards for his work. He was previously a boxer, winning a bronze medal for Northern Ireland at the 1978 Commonwealth Games in Edmonton and a flyweight bronze medal at the 1980 Olympics in Moscow. He is a director of the British Boxing Board of Control.

Martin Nangle studied photography at Belfast College of Art in the early 1970s, and worked in the city as a photographer from 1975, initially as a photographer at the Royal Victoria Hospital before joining Pacemaker Press International, Ireland's main photographic agency, as a photojournalist in 1977. He went on to work in Berlin, Jerusalem, Damascus, Kuwait, Iraq, Cairo and the Balkans for the Associated Press's London bureau. Some of his work is in the permanent collection of the Ulster Museum.

Crispin Rodwell's career spans forty years, including nineteen years for *The Sunday Times* (London) and five years as Reuters' photographer in Ireland, and has taken him to all corners of the world. He has amassed a haul of awards that include Irish Press Photographer of the Year, five-time Northern Ireland Press Photographer of the Year and Nikon UK Regional Photographer of the Year. Since 2000 he has been based in Dublin and is the current president of the Press Photographers' Association of Ireland.

Paul Faith's career began at his local paper, the *Ballymena Guardian*. Before long, his work caught the attention of Pacemaker Press International in Belfast. He joined the agency in 1984 and worked there as a staff photographer until 1999, when he joined the Press Association as a staff photographer, quickly becoming their chief photographer for Ireland. He has won numerous awards for photography, including Press Photographer of the Year three times and Sports Photographer of the Year. He left in 2014 to go freelance and now also looks after Agence France-Presse's interests in Ireland.